Conversations
Photography from the Bank of America Collection

Irish Museum of Modern Art

Jeanne Dunning
Neck, 1990

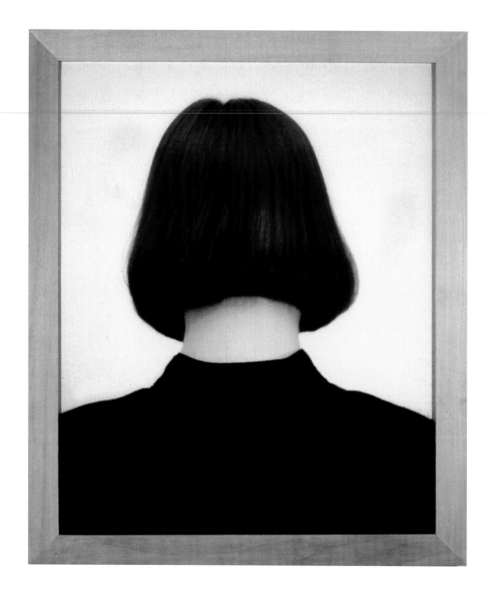

Contents

cover:
Andreas Gursky
*Centre Georges
Pompidou,* 1995

Introduction

The Irish Museum of Modern Art is delighted to present *Conversations*, an exhibition of over 100 photographs from the Bank of America Collection, which documents the evolution of photography and comprises early examples from the 1850s to present day. This exhibition tracks the importance of photography as a medium which has only come to the fore in the last few decades, in terms of its acknowledgement within an art historical context. The Irish Museum of Modern Art has hosted important photography exhibitions in the past; we previously collaborated with the Museum of Modern Art, (MOMA), New York, on an exhibition titled *Picturing New York*, which featured a selection of images highlighting photographers' connections with New York City. In *Conversations*, there is also a link to the Museum of Modern Art as the parameters of Bank of America's renowned photography collection were originally set by leading photographic historians Beaumont and Nancy Newhall who also established MOMA's Photography Department.

This publication reflects the importance of photography as a means not only to document the everyday but also expand our visual lexicon of how we mediate the world around us. The works included in the exhibition document the distant past, such as the *Seascape with Sailing Ship and Tugboat, Normandy*, taken in 1857 by Gustave Le Gray, to our contemporary world of sophisticated museum audiences, documented by Thomas Struth, in his monumental photograph from 2004, *Audience 4*. The catalogue essays highlight the continuing conversations surrounding photography. Anne Havinga and Karen Haas, curators at the Museum of Fine Art, Boston, who chose the works for this exhibition, discuss their selection process and the importance of Beaumont and Nancy Newhall to the formation of the Bank of America Collection and to the history of photography. Matthew S. Witkovisky, The Richard and Ellen Sandor Chair and Curator of the Department of Photography at The Art Institute of Chicago, critiques photography as a means of communication and a signature of discontent, through the works of post war photographers Mike Disfarmer, Robert Frank, William Klein and Harry Callahan. To take us from the post-war period to contemporary photography,

Mary Cremin, Project Curator, IMMA writes on the legacy of Bernd and Hilla Becher and the importance of the Düsseldorf School of photography to the emergence of photographers such as Thomas Struth, Thomas Ruff, Andreas Gursky and Candida Höfer and their relevance to current photographic practices. Both Candida Höfer and Thomas Ruff have previously exhibited at IMMA, and are an important part of the museum's photography collection. Artistic media such as photography are constantly evolving technologically. Photographers today are challenged to make use of new technology while also creating images that arrest the viewer's imagination. This collection reveals a variety of stylistic approaches and demonstrates the power of photography to transfix and suspend a moment.

I would like to take this opportunity to thank the individuals from Bank of America Merrill Lynch who have been instrumental in bringing this exhibition to the Irish Museum of Modern Art; in particular: Allen Blevins, Director of Global Art and Heritage Programs, Lillian Lambrechts, Senior Curator and Collection Manager, Whitney Bradshaw, Curator of Photography, and Emma Baudey, Arts & Culture Manager. I would like to express my gratitude to Anne Havinga, Senior Curator of Photographs and Karen Haas, Curator of Photographs from the Museum of Fine Art, Boston, who both conceived of the exhibition's organizational theme and made the initial selection of works. Finally I would like to extend my thanks to the Irish Museum of Modern Art staff; Seán Kissane, Senior Curator: Head of Exhibitions, Mary Cremin, Project Curator, Gale Scanlan, Operations Manager and Cillian Hayes, Head Technical Supervisor, who provided the support to bring this project to fruition.

ENRIQUE JUNCOSA
DIRECTOR
IRISH MUSEUM OF
MODERN ART

Candida Höfer
Museum Folkwang Essen,
1982

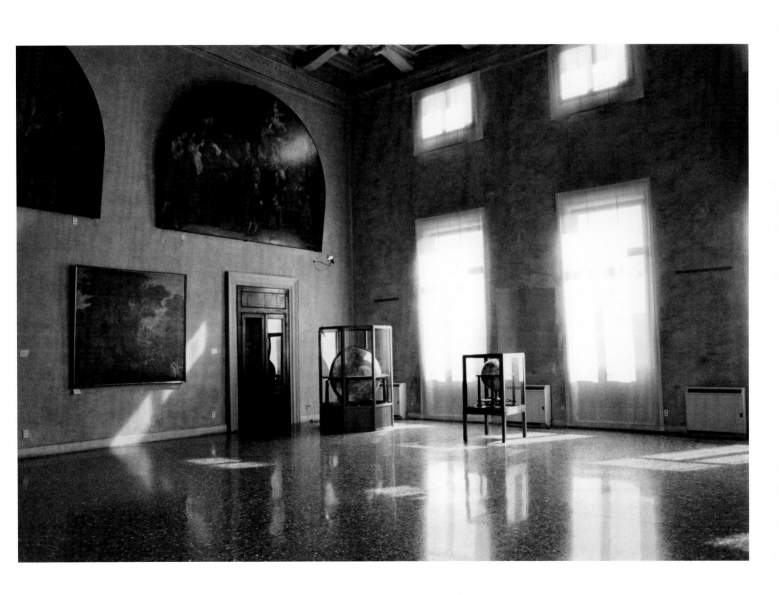

Foreword

Continuing our long tradition of support for the arts, Bank of America Merrill Lynch is proud to partner with the Irish Museum of Modern Art (IMMA) on the presentation of *Conversations*. This photography exhibition is drawn from the Bank of America Collection and is part of our unique Art in our Communities® programme, which has to date, lent more than 50 exhibitions free of charge to museums around the world.

Through its creative and innovative exhibition programme, IMMA makes an invaluable contribution to Ireland's cultural landscape and continues to be a dynamic presence in the international arts arena. We are therefore honoured to have been given the opportunity of enriching IMMA's programme through this exhibition. Our long and fruitful partnership with IMMA began in 2009, through our sponsorship of the travelling exhibition of contemporary American sculptor Lynda Benglis and the loan of two Benglis artworks from our art collection. In 2011 we donated one of these sculptures: *Caelum*, 1986, to IMMA for its permanent collection.

Conversations includes images by some of the world's finest international photographers, all carefully selected from the Bank of America Collection. Considered one of the most diverse corporate collections in the world, it has grown in tandem with the company, continually enriched with art from legacy banks. Each artwork has brought a particular emphasis – regional, thematic, contemporary or historical. Today, the collection comprises paintings, works on paper, textiles, sculptures, historical documents and photography.

The principles and character of the photography collection are owed to the curatorial efforts of Beaumont Newhall. A founder and director of the Photography Department at the Museum of Modern Art (MoMA) in New York in the 1940s, Newhall and his wife Nancy (a knowledgeable photography historian) were asked to create a photography collection for a legacy Bank of America Merrill Lynch company in 1967. Over the next three years they collected approximately 330 works that were both contemporary and international in scope, which built the foundation for today's collection. The Newhalls' vision and standard of expertise continue to be espoused by Bank of America Merrill Lynch curators and museum professionals today.

Conversations was originally presented to the public by curators Anne Havinga and Karen Haas at the Museum of Fine Arts, Boston, and more recently it travelled to the Museo del Novecento in Milan. We are very grateful to Mary Cremin, Project Curator at IMMA, who has re-interpreted the show extremely successfully for the Museum's New Galleries space. Featuring a mix of photographs from both well- and lesser-known artists, the exhibition aims to create dialogue, or 'conversations' between the works, covering a wide range of themes including portraits, landscapes, street photography and abstraction. Together, these images shape the history of the medium. Their engaging juxtaposition helps to spark a visual dialogue, and create a unique exhibition for a wide audience to enjoy.

Bank of America Merrill Lynch has been doing business in Ireland since 1968, and is deeply committed to promoting the country's cultural sector. As one of the world's leading corporate supporters of the arts, we work with cultural organisations across the globe in the firm belief that a healthy arts sector helps economies and societies thrive. Through the provision of grants and sponsorships, as well as our unique Art in our Communities® programme and Art Conservation Project, Bank of America Merrill Lynch helps to facilitate dynamic cultural experiences for the public. We hope that visitors enjoy *Conversations*, a unique collection of works from some of the world's finest photographers.

RENA DE SISTO,
*GLOBAL ARTS AND
CULTURE EXECUTIVE*,
BANK OF AMERICA
MERRILL LYNCH

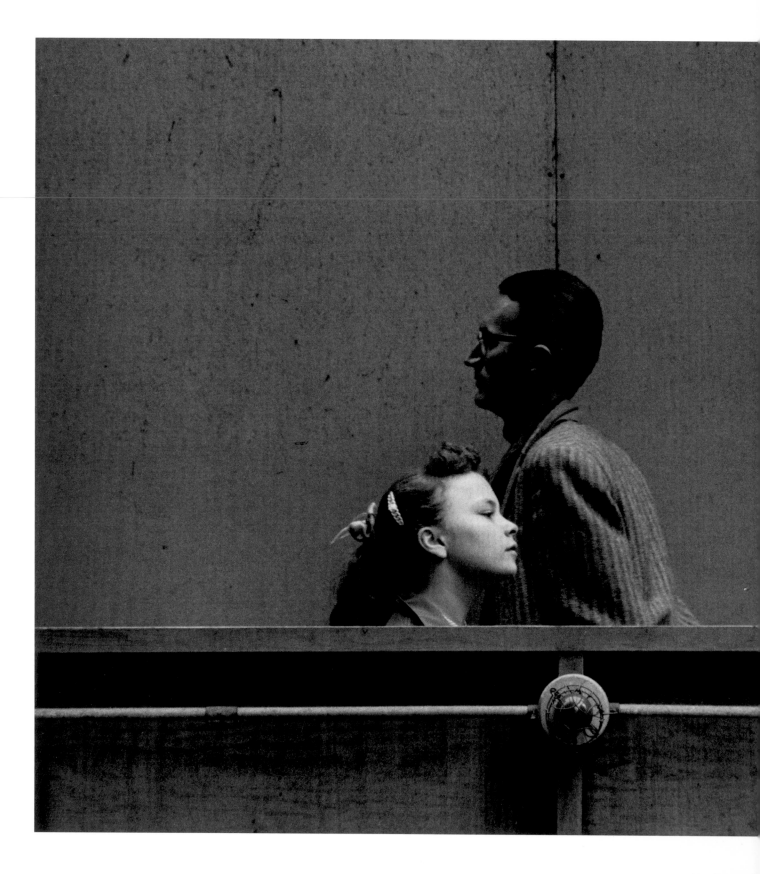

Harry Callahan
Chicago, 1960

Mike Disfarmer
Untitled (Willie Dettweiler,
Vernon Higgs, Heber
Springs, Arkansas), 1946

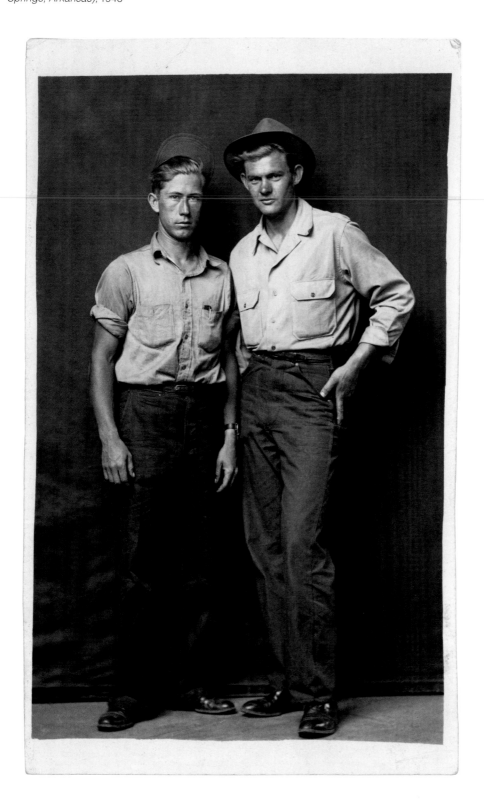

Small talk

A good deal of classic modern photography deals with communication and its discontents. From the 1920s through the 1970s there is a striking continuity of preoccupation with making photographs "speak" while reflecting precisely on the difficulties of talking to one another in the modern world. Urbanisation and modern media technologies established the means to bring people together in previously unimaginable quantities, but these developments also progressively dissolved bonds of community, neighbourhood, and family. As we look over the images in the present book, so many of which involve pictures of people struggling to connect, it is easy to place the context of those struggles in relation to our own age, defined by flash mobs, viral messaging and group scenes filled with people tapping on their phones. There is no face-to-face today without a mediating device that can, moreover, be used equally for texting, talking and taking pictures.

Keeping today's conversational arts in mind makes certain pictures chosen for *Conversations* stand out with fresh force. Four of these pictures, all American and from the first postwar decades, seem to take "messaging" as their particular subject. The first of these (in chronological order) introduces us to Willie Detweiler and Vernon Higgs in the Heber Springs, Arkansas studio of Mike Disfarmer in 1946. By that date, as historian Richard Woodward has noted, Disfarmer was in the end stage of "what should probably be seen as a slow mental breakdown". Born in Indiana in 1884, the man once known as Mike Meyer had petitioned to change his name to Disfarmer in 1939, three years or more after elaborating strange origination stories in which he appeared either as the "real" kidnapped Lindbergh baby or as the cast-off of a tornado that had carried him across the Indiana farmlands and deposited him, like an extraterrestrial alien, in his adoptive family's yard. His name change, he said, was meant to *dis*associate himself from his conventional origins: *not* a farmer of German-American stock (*Meyer* means "dairy farmer" in German).[1]

Disfarmer was mentally disturbed, and he was also a misanthrope: "He wasn't friendly," Woodward quotes one person's remembrance, "He was not talkative."

Disfarmer had perhaps one friend, a local musician; he never married or had children and when he changed his name he also cut all ties with his relatives. He lived, slept and drank heavily in his studio, creating a predictably claustrophobic and pungent atmosphere in which his subjects, according to recollections gathered over recent decades, were asked to pose mostly in silence for up to one hour.[2] Disfarmer, then, was no conversationalist. That he chose to enter the typically gregarious and outgoing profession of studio photographer is downright remarkable, as is the consistently penetrating quality of the poses assumed by his standers ("sitters" seems a misnomer in a space rarely stocked with a chair).

Learning of this context makes one palpably aware of the deliberateness in Disfarmer's studio portraits. Detweiler's and Higgs's stiff poses read as an expression of self-consciousness beyond what might ordinarily be imagined from small-town residents presenting themselves to the camera. The two young men stand in intimate proximity to each other, but they are not at ease; Detweiler, the shorter of the two, has his shoulders drawn back slightly, and seems to wish he could shift just a few inches further from his companion. Higgs is more confident in his gaze, and stands in a relaxed contrapposto (right shoulder back, left leg bent forward) so that he appears both behind and ahead of his mate. This is not a duo, however, but a threesome – Disfarmer is mightily present in the minds of his two subjects. Or rather, Disfarmer with his camera, using his picture machine as a further silent interlocutor, pushing and moulding and surprising the customers until they are made to talk to the camera with their bodies.

The passengers lined up and looking hard at Robert Frank from inside a New Orleans trolley car speak volumes with their bodies as well. *The Americans*, the book from which this iconic picture derives (its contents shot in 1955-56 and published in 1958 and 1959, with this photograph on the cover of the American edition) is typically understood as a landmark study of a country out of touch with its truly modern self. Cars, jukeboxes, flags, television and movie screens and dime-store displays: these are the things that populate

Frank's book. The many individual types who appear in the book – a cowboy, a wet nurse, a preacher, an elevator operator – appear to be struggling for a place in this insistently technologised and secularised American landscape. As Sarah Greenough comments in introducing the definitive study of Frank's landmark book: "He depicted a society numbed by a seemingly endless array of consumer goods that promised many choices but offered no real satisfaction, and he revealed a people emasculated by politicians who were fatuous and distant at best, messianic at worst."[3]

A striking number of photographs in *The Americans* deal with religious salvation, the artist's deep-seated and convincing suspicion of messianism notwithstanding, and they do so not only in a critical manner. Crosses (four) vie for frequency of depiction with American flags (five, plus two flag-like banners), and because three of the pictures with crosses appear in a row, their impact is emphatic. Then there are the several scenes of funerals and funerary items; one picture of a car with bumper stickers about Jesus Christ, another of a Jehovah's Witness holding up the association's publication, *Awake*, and a third of a group of Orthodox Jews celebrating Yom Kippur; as well as pictures of redemptive symbolism, such as the famous view of a ribbon of blacktop zipping toward infinity under a luminous sky, or the one of a filling station over whose tanks a busted neon sign rises with the single word: SAVE. There is irony, of course, in these images, but not antipathy to religiosity per se.

Trolley – New Orleans, 1955 could be read in this context as an altarpiece, divided horizontally into five panels and vertically into three sections. The window frames, also suggestive of prison bars, create an episodic narrative style in the manner of altar painting. The glass windows at top, meanwhile, recall with their shadowy reflected figures a predella or series of vignettes that is usually placed underneath (rather than over) the main panels of the altarpiece. Frank has composed a scene of human suffering and injustice with a mixture of engagement and equanimity that, again, is worthy of Renaissance panel painting. The black man caught at the dividing line between white and coloured ridership looks straight out at Frank, and

thus at us, with a beseeching gaze that is heartrending yet absolute: he is a martyr to indifference. Behind him, a fellow African-American rider looks outside the frame and thereby reminds us as viewers of the scope of the world that should bear witness to this scene. The older of the white children at centre, of an age to perpetuate discrimination but not to understand its causes, looks outward in his jacket and bowtie with an ignorant self-assurance, while the grown woman one row in front of him hardens her facial expression into what a liberal conscience reads as a mask of defensive hostility. None of these passengers will talk to the others, but all of them talk to us through the camera. The frame of glass and painted metal that surrounds them (and blurs the frontmost passenger on our side) gives us the space we need to reflect on our own part in this morality tableau.

Five years further on, and *The Americans* had appeared in print, changing the discussion of photography's core tactics and values for good. The world in which Harry Callahan made his second series of studies of passersby lost in thought, in 1960 and 1961, was irrevocably different to that in which he made the first series, in 1950. A sense of formal composure – a picture utterly composed to the photographer's preferences – had in America given way to slackness, rawness and immediacy in photography, an approach that held its own formal promise and conveyed a new social awareness as well. William Klein's *Four Heads, New York* ,1954, part of a book-length project on that city, filled with grain, blur and anomie, had set the tone for a mid-century sensibility in which people rushed past one another, jostling as they passed but never making eye contact.[4] Callahan shared that sensibility but he had other interests as well. The city (Detroit or Chicago in his case) was not a blur of built and human elements, but an immutable graphic composition. The movement was all in Callahan's camera, as when he exposed the same negative multiple times or moved the camera body around during exposure to transform streetlamp beams into swirling tracks of light.

To interpret *Chicago,* 1960 as an emblem of the loneliness of city life thus seems a bit misplaced; the quality of "aloneness" in Callahan's photographs is existential, it is both modern and beyond the reach of historical time. Stillness is the first sensation one experiences in looking at any of his works, particularly the photographs such as these that show anonymous pedestrians in what one imagines to be an ordinarily noisy city. (Chicago, with its elevated subways and dense urban core, is particularly loud on the street.) The many prints in which Callahan radically reduces contrast to a near black or white flatness seem to have been put through the visual equivalent of extreme noise filtering – a hush lays over them. This also means that all conversation has been silenced. We are left to contemplate, in a way that the gentle and ruminative abstract painter Agnes Martin is said to have particularly admired, the precision of Callahan's perfect or (no less deliberately) near-perfect alignments.[5] There is most prominently the fissure that separates two concrete wall panels, which descends at the centre of the composition until it exactly meets a wooden support stud and bulb in the lower half of the picture; this same fissure forms an exquisite T shape in juxtaposition with the horizontal electrical conduit. Against this geometric rapture we see the pale, illuminated face of the shorter lady set off against the darker tones of the taller man, whose face is caught in shadow, and a similar contrast of her hair accessories against his eyewear. Every detail of the picture, in short, has its complement or continuation in another detail. The world is hushed in silence, but the parts of it that feature in this composition are locked in a mute yet incessant dialogue.

No more pointed contrast could be found to Callahan's soundless twosome than the bench full of rowdy socialites captured by Garry Winogrand at the edge of the New York World's Fair, in Queens in 1964. We see animated talk of all kinds in this fantastic group scene, which takes as its backdrop the fountain surrounding the openwork metal globe that still stands at what was the entrance to the main fairgrounds. The various motions made by the occupants of this are multiplied in their energy by the surge of visitors strolling across the lawn, and the fountain whose jets wash the horizon.

Not far from that bench in Flushing Meadows Park rose the New York State Pavilion, a centrepiece building

designed for the Fair by architect Philip Johnson. On its façade there hung briefly a mural by Andy Warhol entitled *Thirteen Most Wanted Men*, a five-by-five grid of silkscreened single images and diptychs showing a baker's dozen of mostly Italian lawbreakers in police mug shots. The work included profiles as well as frontal views, such that the men seemed to be talking each to the next across the borders of their images. In a particularly bold compositional move, Warhol left the final three slots of his composition blank, as if to keep open a space for viewer projections of their own outlaw desires.

The mural was soon whitewashed to satisfy the overall commissioner of the World's Fair, the urban planner Robert Moses. As Richard Meyer has observed, the destruction of Warhol's work did not just censor the portrayal of criminals, it served also to reinforce the criminalisation of homosexual desire. The subversiveness of his proposal for the pavilion inhered most strongly, as Meyer argues, in "the circuitry set up between the image of the outlaw and Warhol's outlawed desire for that image... and for these men.... [T]he very act of 'wanting men' constitutes a form of criminality if the wanter is also male, if, say, the wanter is Warhol."[6]

Winogrand's photograph is much less provocative than the work by Warhol, who also in that year made his films *Blow Job* and *Taylor Mead's Ass*; the collection in which Winogrand later placed this picture is titled with innocent heterosexual exuberance, *Women Are Beautiful*. But the photograph presents a show of unformed youthful sexuality that is open to all sorts of conversations. There is the couple on the left, having what looks to be a genuine and friendly exchange of views – she exclaiming over something, he listening earnestly with one hand resting in sympathetic proximity to her sleeveless arm – all well and good, except that he is black and she is white, and that is a pairing whose appearance in public is never to be taken for granted. There is the threesome in the middle, giggly girlfriends in matching knee-length dresses and preppy loafers, lost in conspiratorial discussions; must one imagine that such active young ladies sit simply awaiting Winogrand's (our) gaze, or to press the point, must one think that their own desires necessarily centre

on men? Then there is the pair of young ladies turning, arrested, to look "offscreen", one of whom lowers her sunglasses in what could be disbelief or attraction, while the other presses against her companion while adjusting her own hair with a reflexive coquetry. To their left sits a final participant, a much older man who may or may not be fully attending to his newspaper reading. His presence creates the involuntary suggestion of an illicit liaison with the two enraptured ladies – indeed with the whole orgiastic benchful – a thought that brings decent talk quickly to a close.

The exchanges pictured by or imagined for these four photographs are respectively more taciturn, questioning, solitary or permissive than is allowed in polite conversation. The photographs create a distance from real human interaction but at the same time they generate a new and more insightful vocabulary to describe it – the rare gift of true art. To bring such works together, as this exhibition does, is to refresh our normal discussions about what it means to talk together; a discussion that always needs updating, as fresh ideas come into the world of art and fresh forms of community and communication reshape the social landscape.

MATTHEW S.
WITKOVSKY
*RICHARD AND ELLEN
SANDOR CHAIR AND
CURATOR*
DEPARTMENT OF
PHOTOGRAPHY
THE ART INSTITUTE
OF CHICAGO

[1] Richard B. Woodward, "American Metamorphosis: Mike Disfarmer and the Art of Studio Photography," in Edwynn Houk, ed., *Mike Disfarmer: The Vintage Prints* (New York, 2005), pp.206-07.

[2] See also Toba Pato Tucker, *Heber Springs Portraits: Continuity and Change in the World Disfarmer Photographed* (Albuquerque: Univ. of New Mexico Press, 1996), with an outstanding essay by Alan Trachtenberg; and Julia Scully, *Disfarmer* (Santa Fe: Twin Palms, 1996); Scully's observations first appeared in *Aperture*, number 78 (1977) to accompany an exhibition of Disfarmer's posthumously celebrated work at the International Center of Photography, New York.

[3] Sarah Greenough, *Looking In: Robert Frank's* The Americans (Washington, DC: National Gallery of Art, 2009), pp.xix-xx. For a listing of Frank's categories in shooting *The Americans*, see ibid., p.121.

[4] See Sandra S. Phillips, ed., *William Klein: Life is Good and Good for You in New York: Trance Witness Revels* (San Francisco: San Francisco Museum of Modern Art, 1995). Klein's book *Life is Good and Good for You in New York!* first appeared in 1956.

[5] I thank Peter MacGill for his recollection of a conversation he had with Agnes Martin while the two of them looked at works by Harry Callahan. MacGill to the author, September 28, 2011.

[6] Richard Meyer, "Warhol's Clones", in *Negotiating Lesbian and Gay Subjects*, eds. Monica Dorenkamp and Richard Henke (New York: Routledge, 1995), pp.97-98, quoted in Douglas Crimp, "Getting the Warhol We Deserve: Cultural Studies and Queer Culture," *In/Visible Culture: An Electronic Journal for Visual Studies*, 1999, posted online at http://www.rochester.edu/in_visible_culture/issue1/crimp/crimp.html#46 (accessed October 2011).

Walker Evans
Penny Picture Display, Savannah,
1936

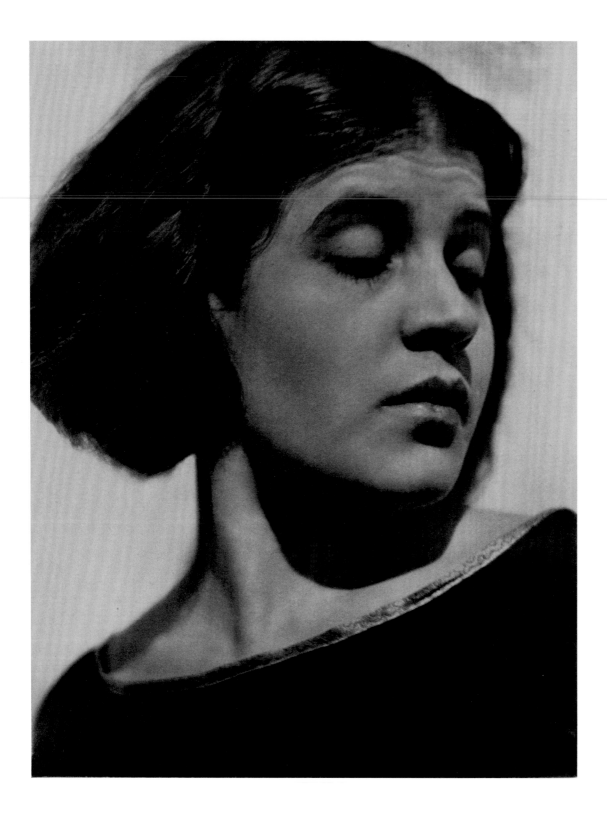

Carrie Mae Weems
Untitled, Outtake from the
Kitchen Table Series, 1990

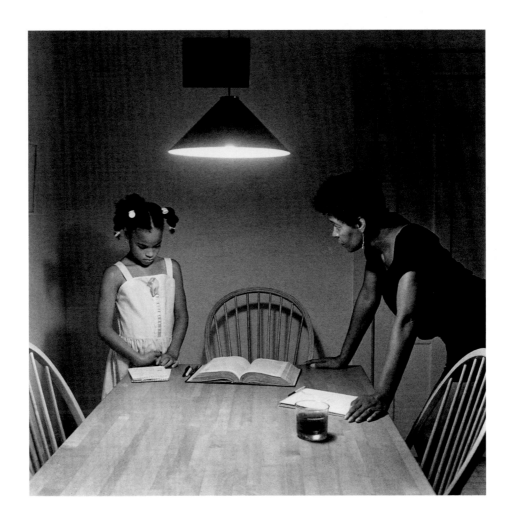

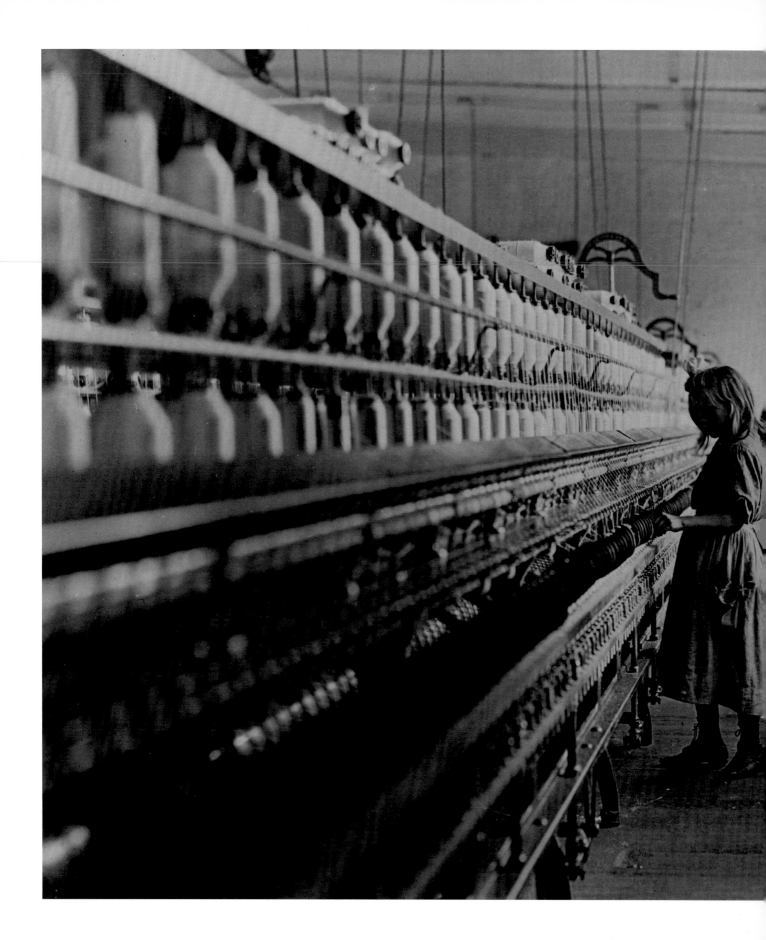

Lewis Wickes Hine
Child Labour, c. 1908

Man Ray
Portrait of Nancy Cunard
1925

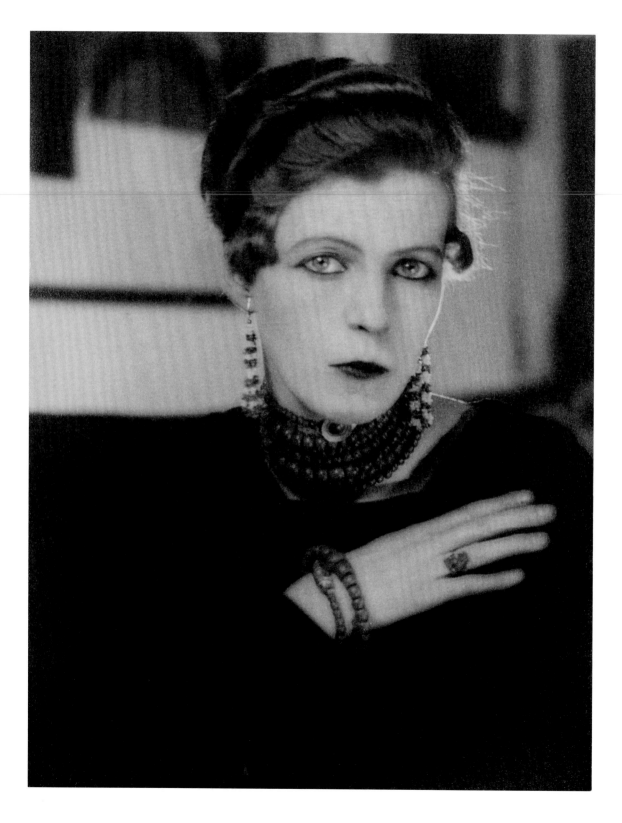

Julia Margaret Cameron
Untitled (Mary Emily 'May' Prinsep),
1870

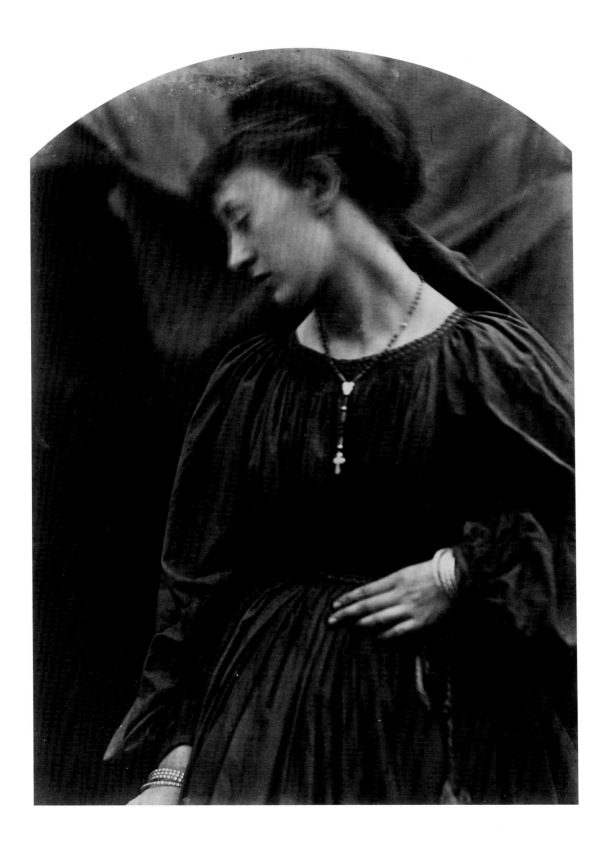

Maurice Tabard
Jardin des Modes, 1931

Edward Steichen
Paul Robeson as
"The Emperor Jones"
1933

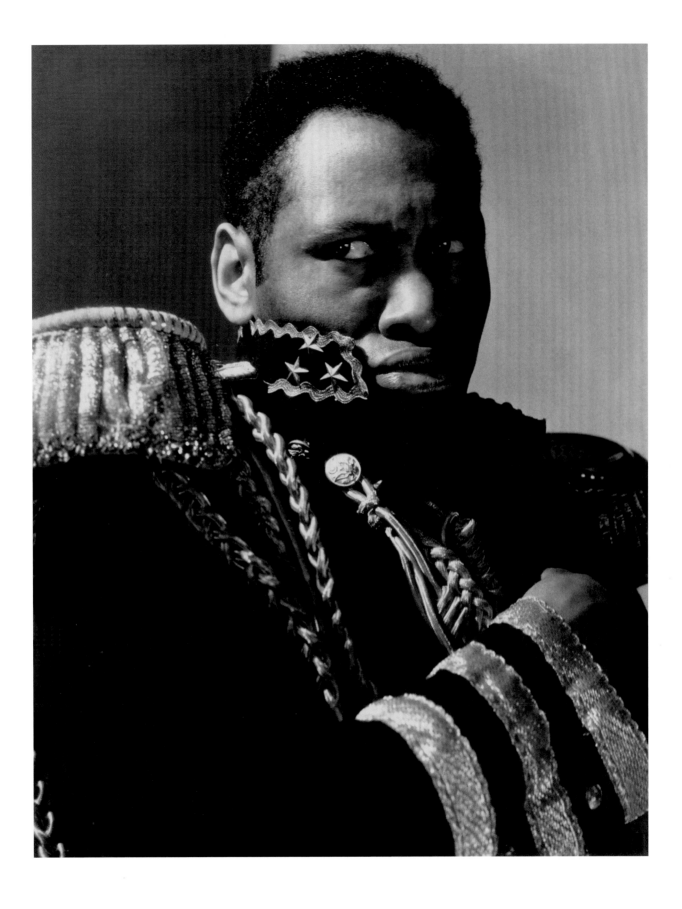

Hellen Van Meene
Untitled, 1997

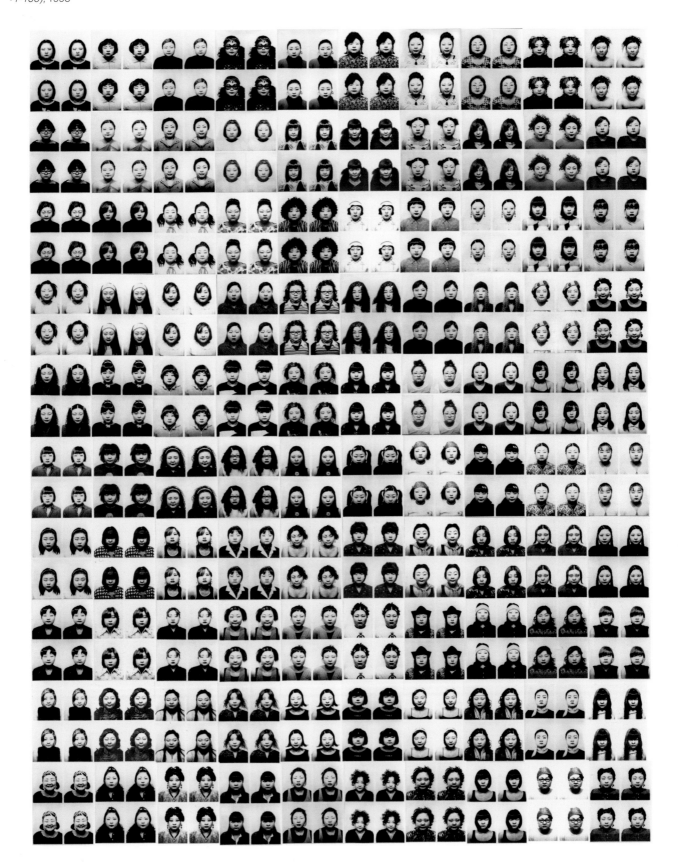

Ben Gest
Chuck, Alice and Dale, 2003

William Eggleston
Untitled (Memphis), c.1970

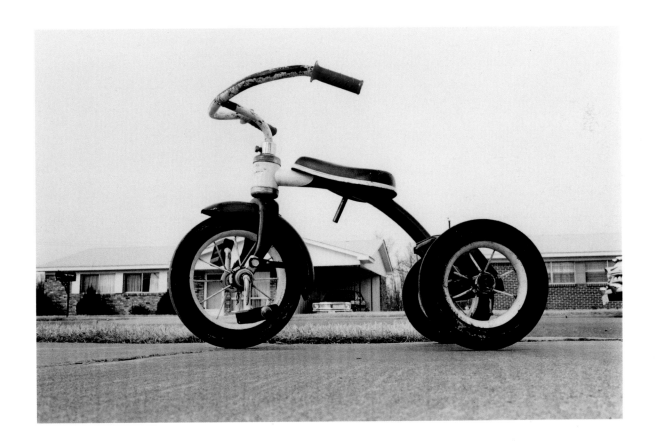

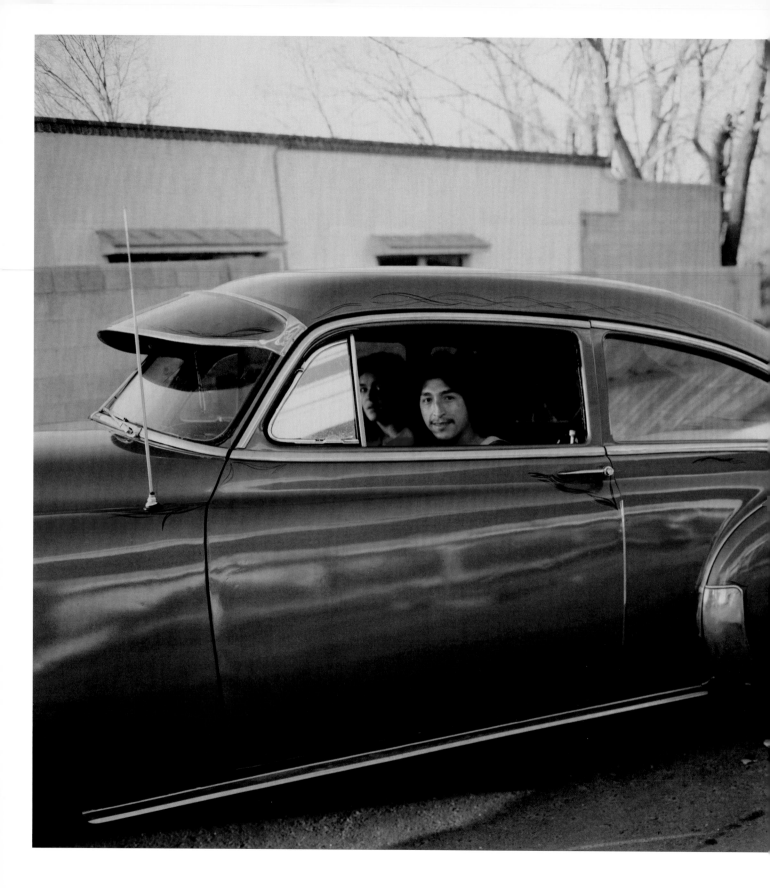

Meridel Rubenstein
*Donaldo Valdez, El guique, '49
Chevy from "The Lowriders,
Portraits from New Mexico,"* 1980

Theo Baart
Hoofdweg, 1997

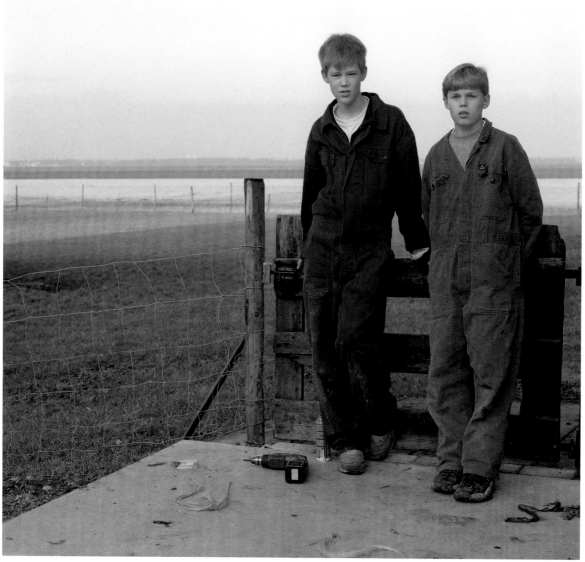

Jem Southam
Blue Gate, Holland, 2003

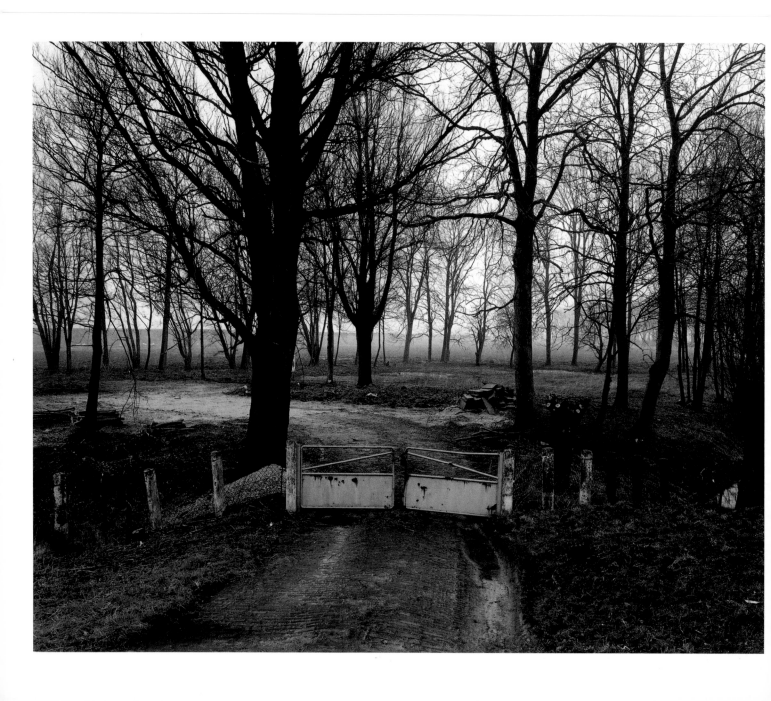

Mike Smith
Unicoi, TN, 1998

Art Sinsabaugh
M.W. La #34, 1961

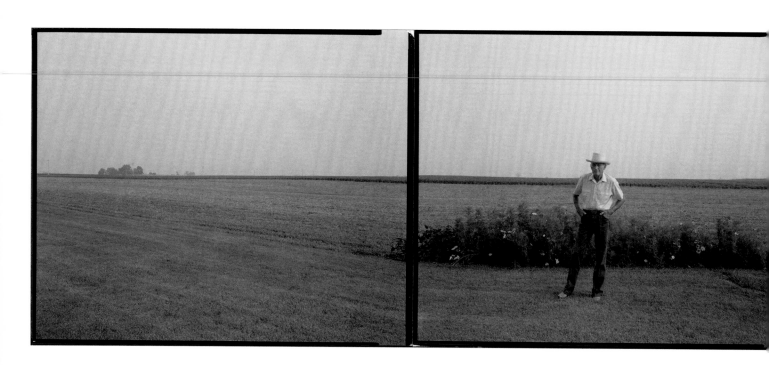

Rhondal McKinney
Riley Thompson, Lane, Illinois:
from the series *Farm Panorama,*
1985

Minor White
Vicinity of Dansville, New York,
1955

Rodney Graham
Welsh Oak (#4), 1998

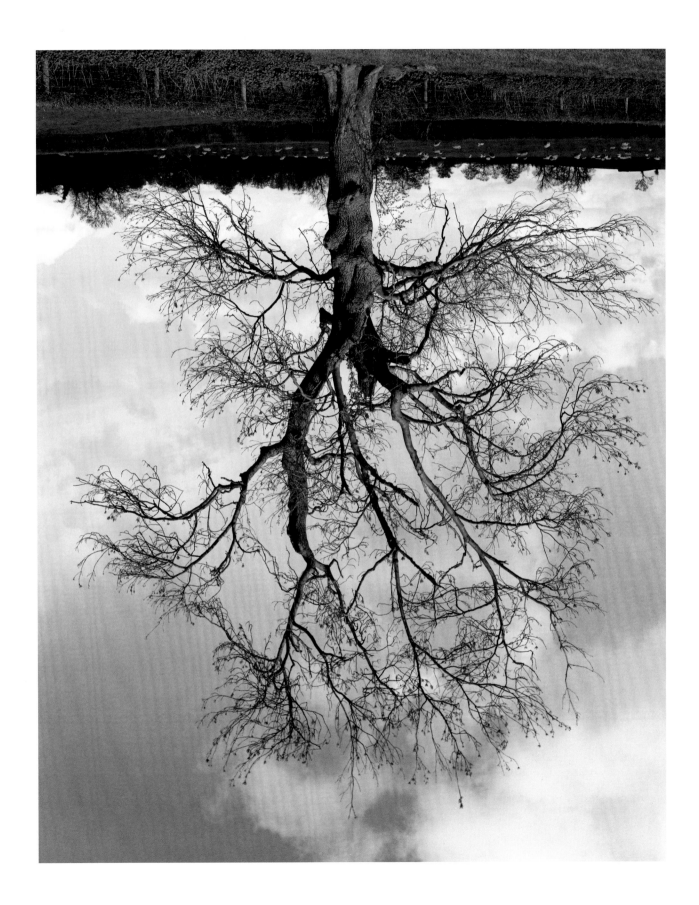

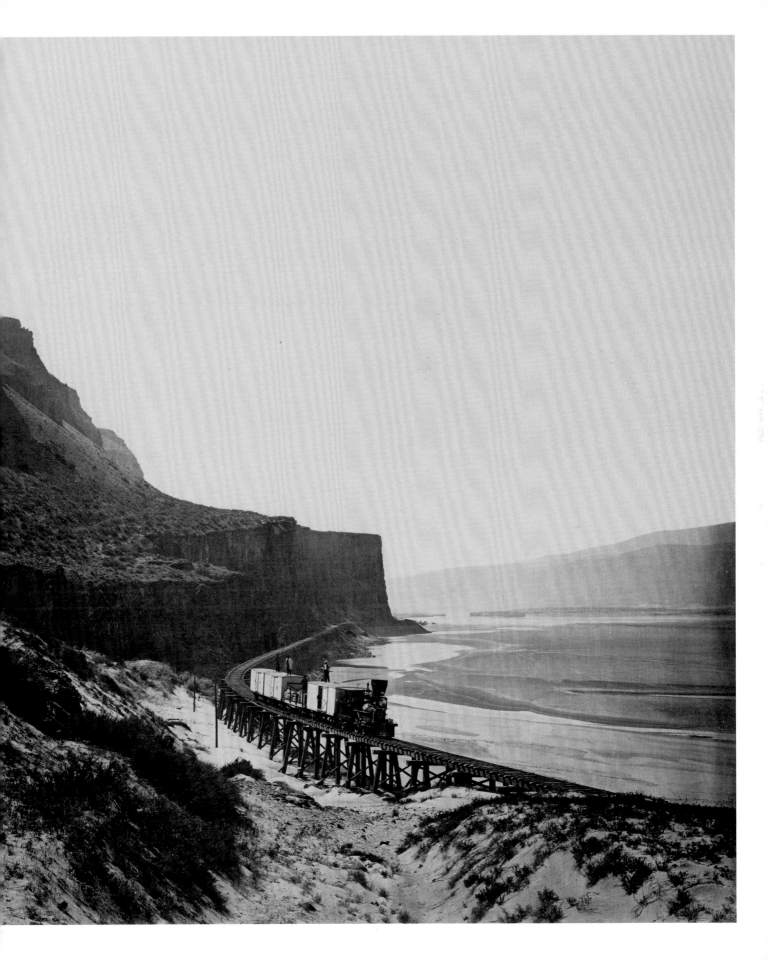

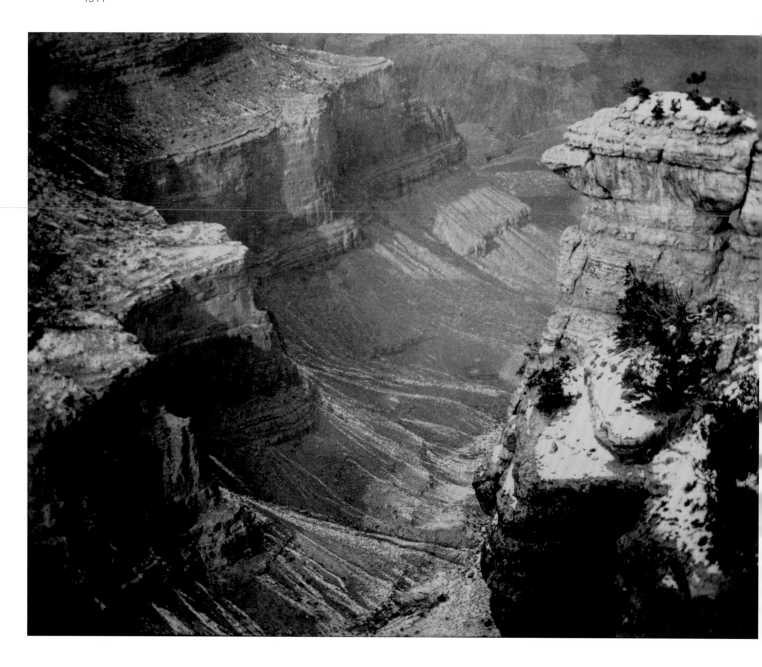

Timothy H. O'Sullivan
*Ancient Ruins in the Canon
de Chelle, N.M.,* 1873

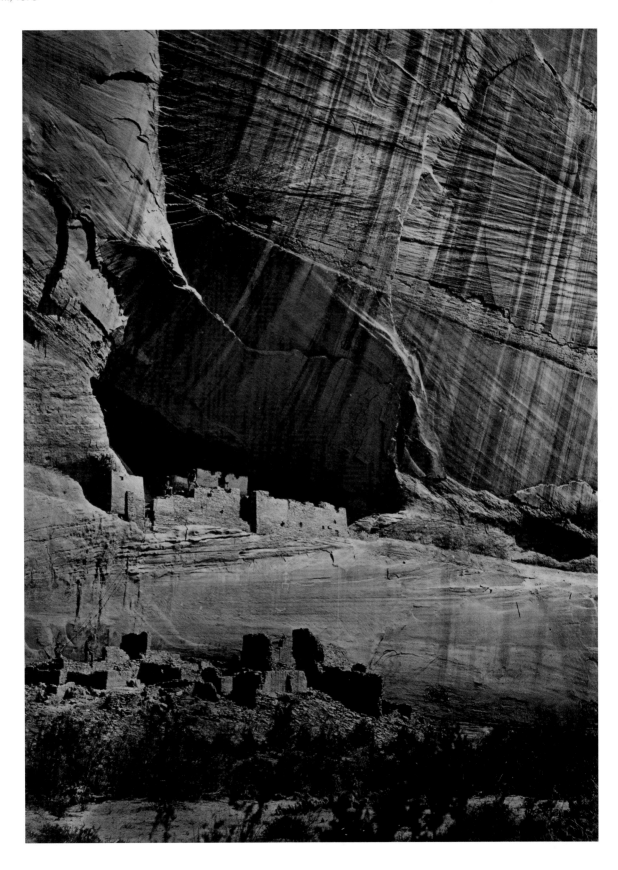

Kenneth Josephson
New York State, 1970

Hans Aarsman
Launching, Waterhuizen, 1988

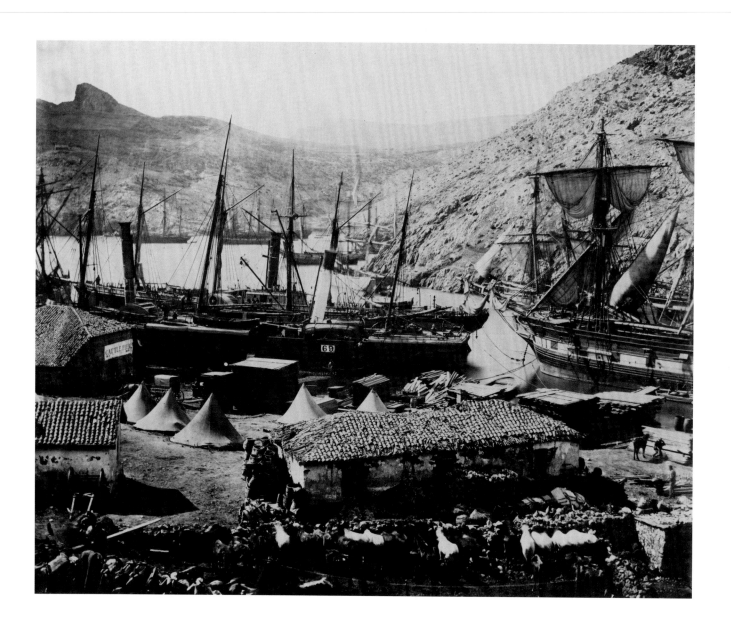

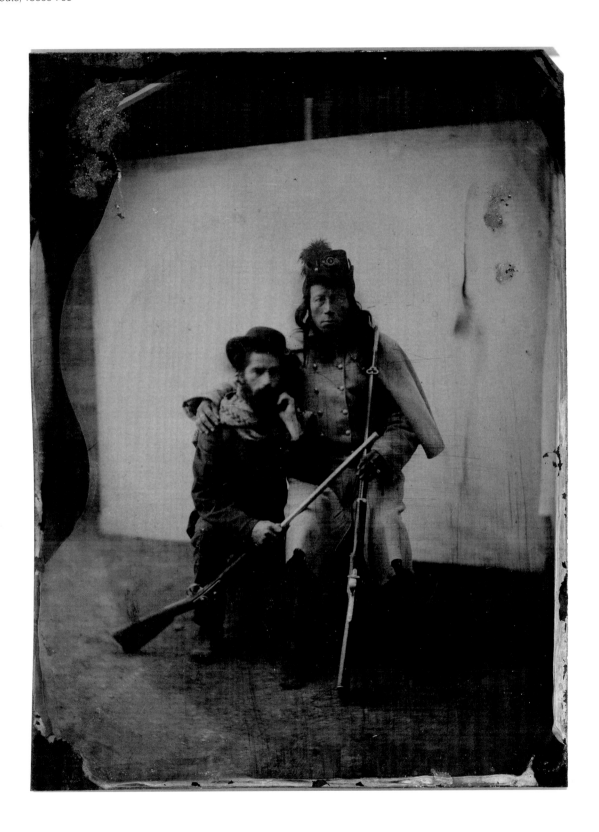

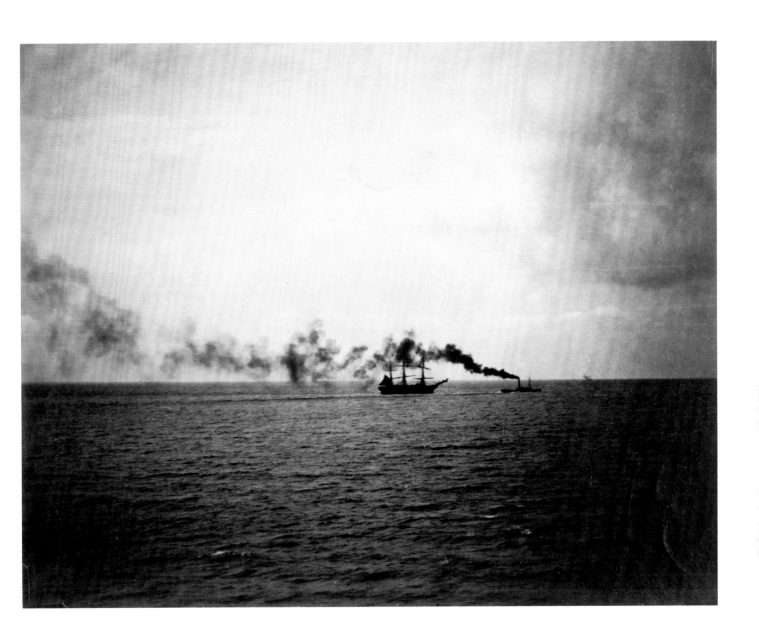

Hiroshi Sugimoto
North Pacific Ocean, Mt. Tamalpais,
1994

Hiroshi Sugimoto
Ionian Sea, Santa Cesarea III,
1990

Graciela Iturbide
El Sacrificio, 1992

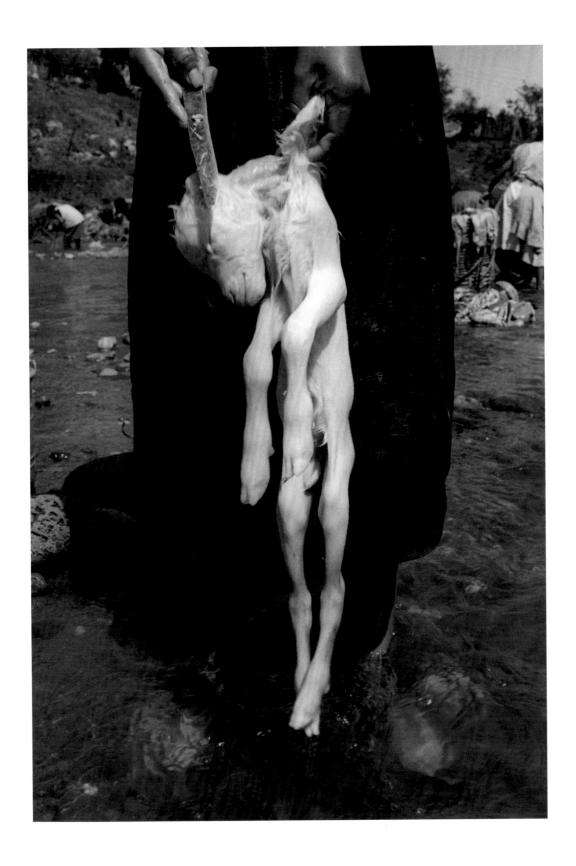

Paul Strand
Toadstools and Grasses,
1928

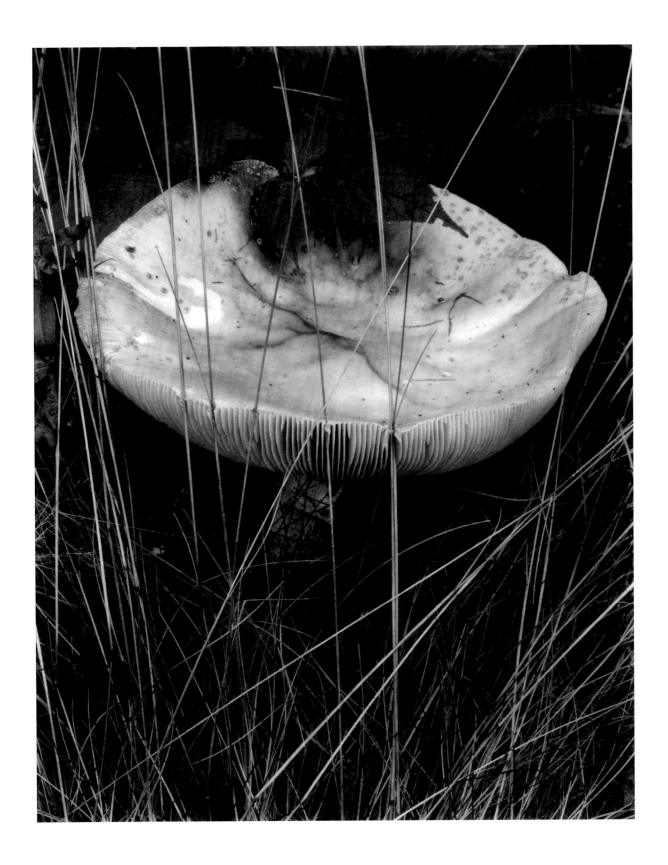

Jan Groover
Untitled, 1978

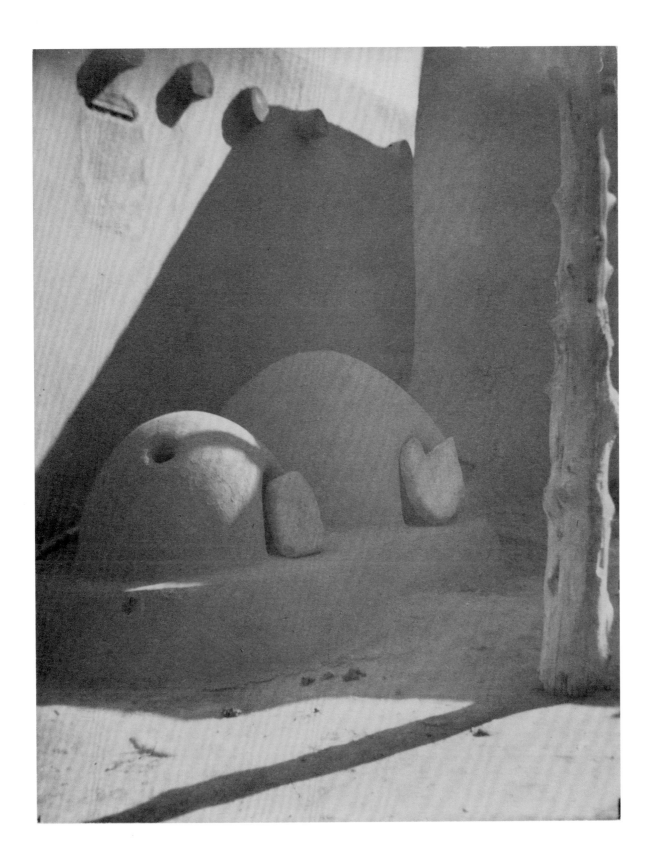

Andreas Gursky
Centre Georges Pompidou,
1995

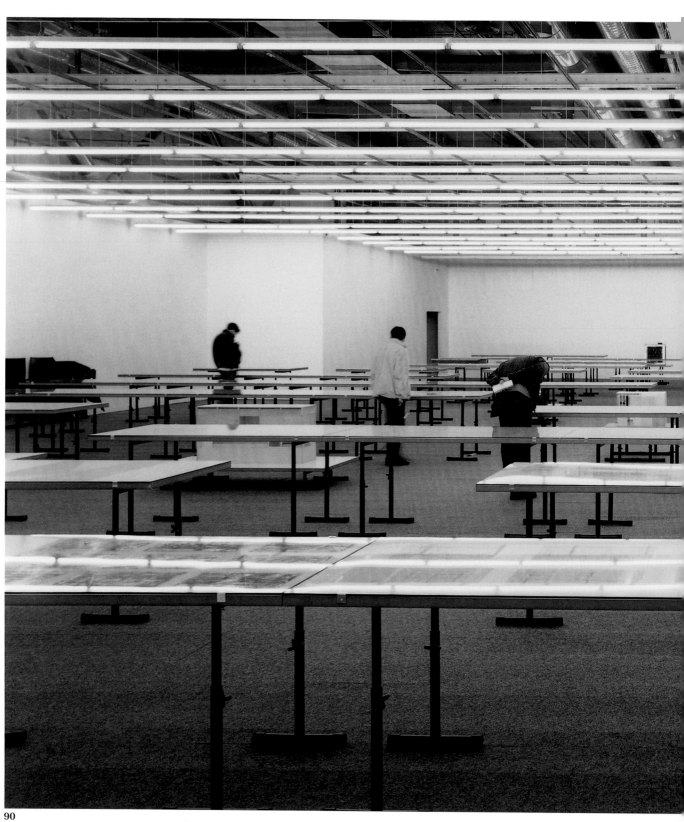

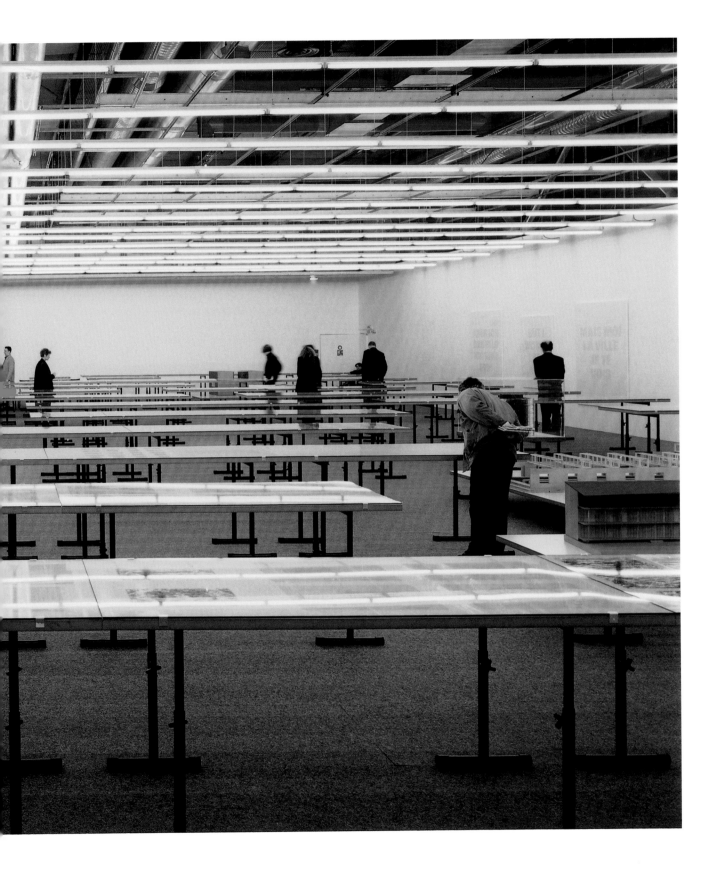

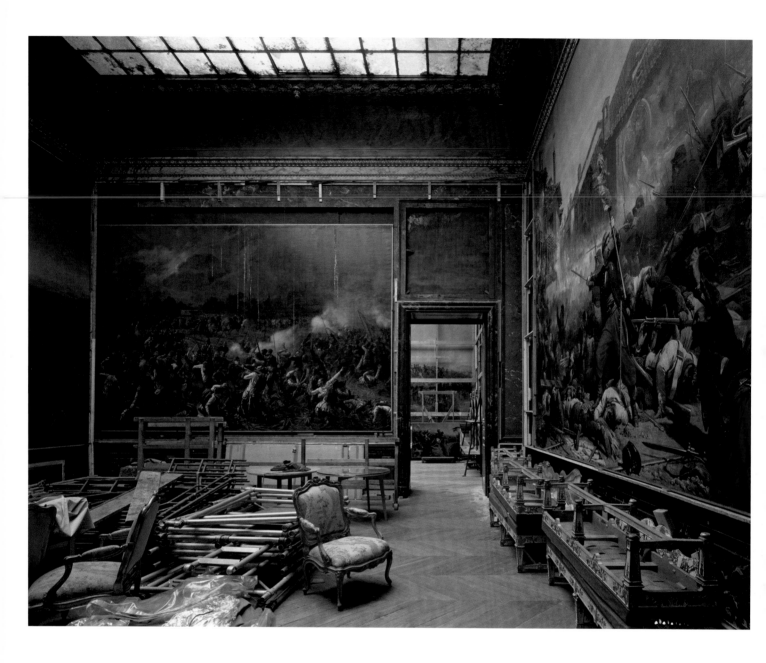

Thomas Struth
Musée du Louvre 4, Paris,
1989

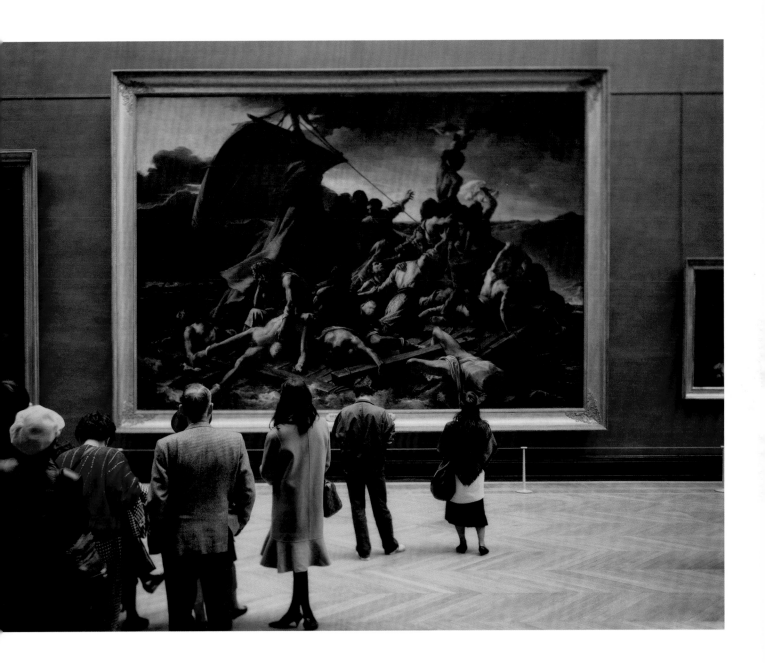

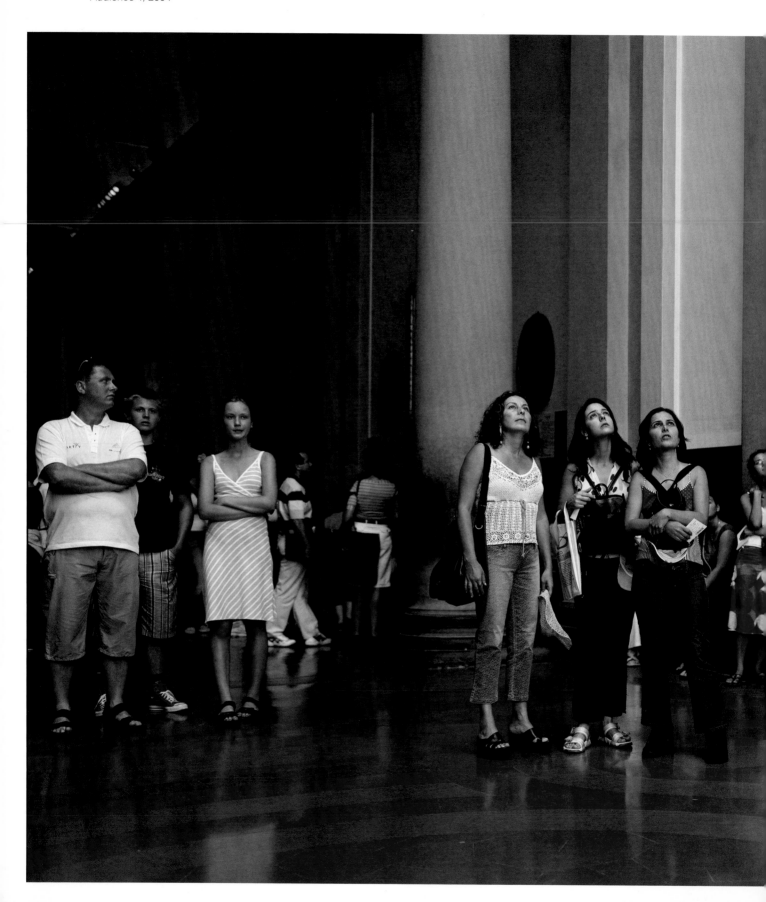

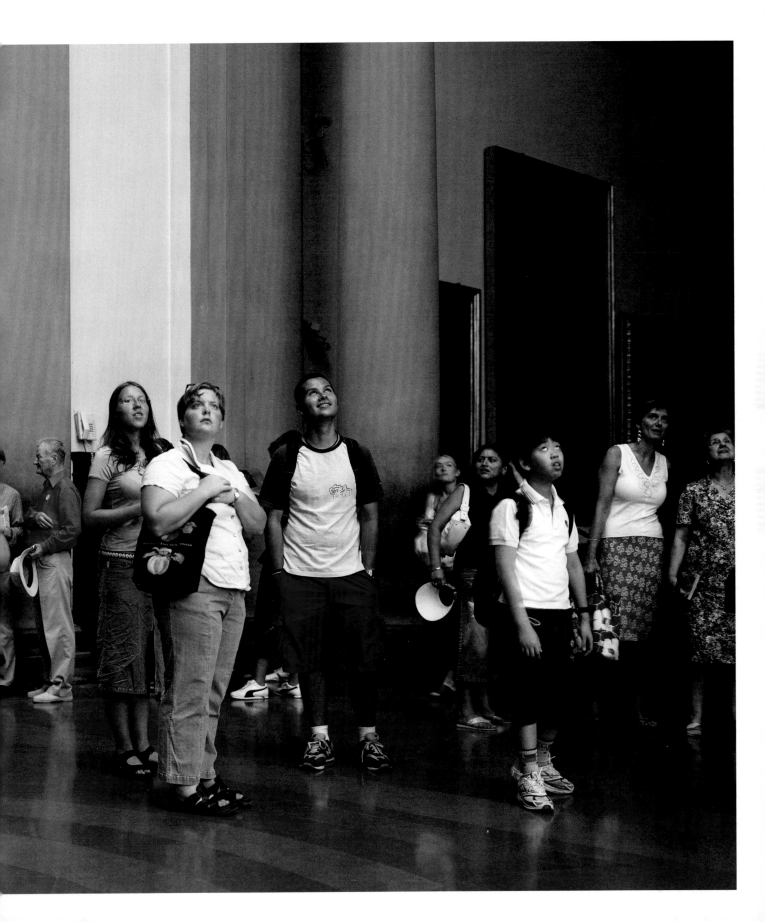

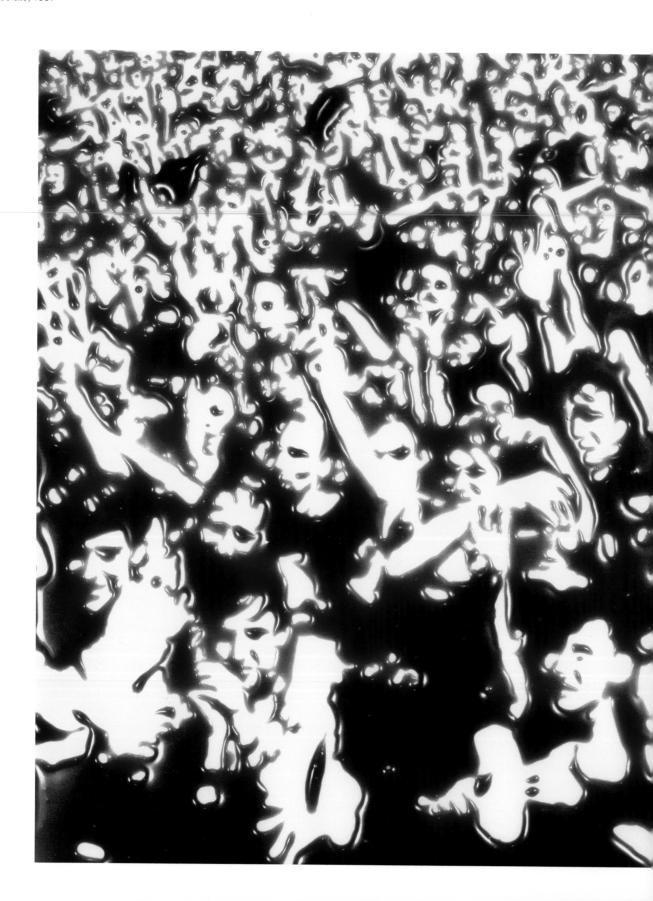

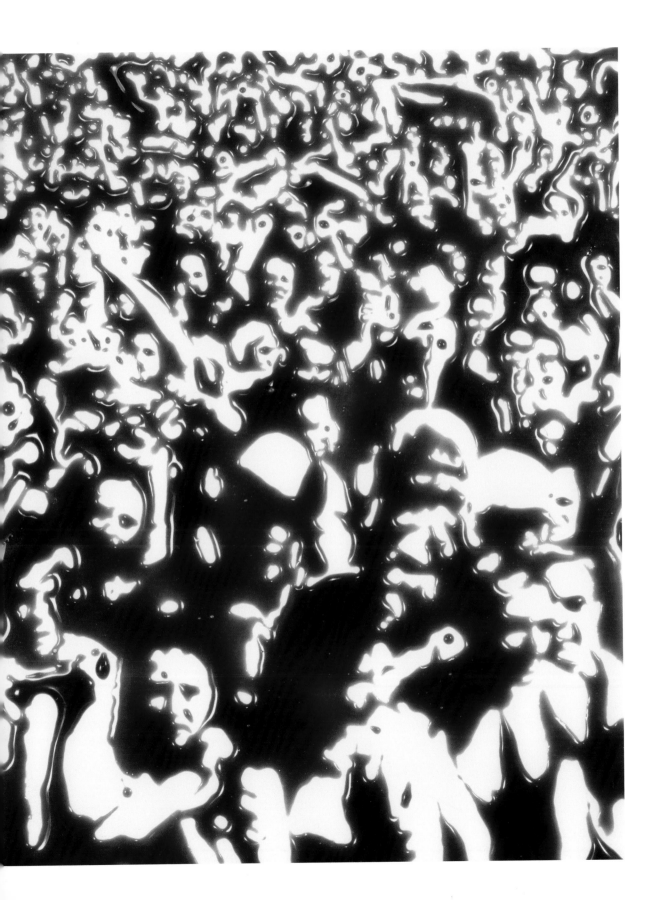

Making Conversations

The Museum of Fine Arts, Boston, was extremely pleased to organise an exhibition of highlights from the extraordinary Bank of America Collection. As curators, we chose to concentrate on an aspect of the Collection that was significantly influenced by the scholars Beaumont and Nancy Newhall, who, starting in the late 1960s, assembled a core group of works for The Exchange National Bank of Chicago, a legacy Bank of America company.

When they served as the bank's advisors, the Newhalls were the most eminent historians of photography of their time. Beaumont Newhall started his distinguished career at The Museum of Modern Art, New York, where in 1937 he organised a landmark survey of the first hundred years of the medium. His classic text, *The History of Photography: From 1839 to the Present,* helped photography gain acceptance as a vital force in the history of art. Later on, he served as curator and director of the prestigious George Eastman House in Rochester, New York, and following that, was a professor at the University of New Mexico, where he established the first doctoral programme in the history of the medium. Nancy Newhall was also an important historian of photography, substituting for her husband at MoMA while he served in World War II, and writing numerous articles and books, both scholarly and popular.

The decade during which the Newhalls worked for the Exchange Bank was a pivotal one for photography. The 1960s brought new awareness of the significance of photographs as fine art. As photographers became successful not only for their commercial activities, but also for their personal artwork, galleries dedicated to the medium began to open up, and many museums started to build collections. A few far-sighted individuals, including executives at The Exchange Bank , took note of this development and also began to acquire photography.

Beaumont and Nancy Newhall were then asked by the bank to assume "the challenge of making great photographs a living, moving part of the lives of all the people who come to the bank – those who work there as well as those who bank there." Following this mandate, the Newhalls bought with connoisseurship

in mind, accumulating the beginnings of a collection that was broad in scope, representing the entire history of the medium. It was at this point that the bank was acquired by Bank of America. To this day, the Newhall's standards are continued by subsequent curators, and thanks to these efforts, Bank of America's superb collection is richly varied.

The bank viewed the sharing of this major collection as a demonstration of its "commitment to the idea that creativity is a universal springboard in business as in life." As curators of this exhibition, we attempted to develop an inventive approach to presenting the Collection's highlights. Arranging the photographs by theme – portraits, still lifes, landscapes, documentary images and experimental abstractions – we sought visual 'conversations' between the more than one hundred works in the exhibition. Thus, nineteenth-century photographs are compared with examples from the twentieth century, close-ups are paired with distant views, and staged subjects are shown alongside documentary ones.

One of the remarkable aspects of Bank of America's contemporary holdings is the number of pieces in which monumental works of art are the central subject. By placing these front and centre, we hoped to encourage audiences to think of the exhibition as one that was essentially about ways of looking at art. In his well-known series of museum photographs, of which we chose three, Thomas Struth draws attention to the body language and facial expressions of visitors reacting to major masterpieces. In his images of Versailles, Robert Polidori focuses on the richness of galleries that are continually renovated by generations of staff, and Candida Höfer, in the works we chose, captures the play of light and shadow on museum walls, conveying something of the actual experience of strolling through art-filled spaces. Thomas Ruff's beautifully blurred depiction of Mies van der Rohe's Barcelona Pavilion, the German contribution to the World Exposition of 1929, fuses structure with landscape, evoking for some of us the quick glance with which many first take in a work of art.

A large number of images in the exhibition fall loosely under the heading of portraiture, but these range widely in style and approach. One pair of portraits that particularly seem to speak to each other is Julia Margaret Cameron's stunning likeness of her niece, May Prinsep, and Edward Weston's close-up image of his lover and muse, Tina Modotti. Formally very related but separated in time by more than fifty years, the two women's eyes are similarly downcast and the simple lines of their dresses beautifully set off the curve of their necks and their gently bowed heads. However, the Cameron, a late nineteenth-century photograph made with the long exposure required of the wet collodion process, conveys surprisingly modern, life-like qualities, while the 1920s platinum print by Weston, taken with a hand-held camera in the brilliant Mexican sun, has an unexpectedly monumental, almost classical, feel to it.

Many of the photographs in the Collection are, in fact, self-portraits, and a number are carefully staged, although not always obviously so. For example, Cindy Sherman's grainy, deadpan *Film Still #50*, features the artist seated stiffly in a set-like interior having transformed herself into a B-movie actress in order to remind us of the subtle, yet powerful, role that the media plays in all of our lives. Japanese photographer Tomoko Sawada also explores the idea of performative portraiture in her work, in this case exploiting the perceived truth of the ID card picture repeated here in a hundred likenesses, each one seemingly very different, but all of the artist herself. Carrie Mae Weems also takes centre stage in many of her images; in her out-take from the *Kitchen Table* series, for example, she plays the role of a stern African-American mother in mute interaction with her young 'daughter', leaving the viewer to imagine a variety of scenarios and calling into question the idea of the photograph as document.

Colour photography of American domestic life, mostly dating from the 1970s to the present, is another major facet of the Collection. The great depth of this material allowed us, for example, to hang three images of fathers in a memorable sequence. First, Larry Sultan's *The Green Wall*, which perfectly captures the emotional disconnect between husband, wife and artist-son – the latter out of view, but still very much a presence – following the sudden loss of the father's high-powered job.

Felix Gonzalez-Torres
Untitled (Sand), 1993-94

Second, Mitch Epstein's haunting image of his father's battered leather briefcase, representing the demise of the family's furniture business and their American dream. And finally, David Hilliard's sensitive triptych of his father, as seen through a softly lit window at twilight, that speaks of the complicated relationship between a young gay man and his aging working-class parent, a man whom the artist sees as a tragic, yet sympathetic figure. Perhaps the most significant picture in this larger group of domestic subjects is, however, William Eggleston's iconic image of a tricycle looming over a suburban Memphis street. Shot from almost ground level with a wide angle lens, this pioneering colour photograph, like many of the works in this series, takes a simple, quotidian subject and transforms it through the camera's lens into something strangely ominous, even sinister.

The landscape photographs that we chose traverse time and geography. The earliest example in the exhibition is by Félix Teynard, one of the first artists to record with a camera, in 1851-52, the ancient sites of Egypt. Using the paper negative process, and making softly tonal salt prints, the Frenchman found himself drawn to intimate architectural details, contrasting in his images the massive stone with the delicacy of its carved decoration. The British artist Francis Frith, who visited the country a few years later, mastered the newer techniques of glass negatives and albumen prints that had the capability of rendering subjects with greater clarity. Focusing on the grandeur of the monuments, Frith's mission was to create iconic images that ultimately set the standard for the visual recording of the sites for future generations. Travelling in the late 1980s, the American Richard Misrach interpreted what he observed in Egypt by capitalising on his sublime sense of colour combined with a contemporary appreciation of irony.

Other selections of landscapes offer different types of 'conversations'. Pictorialist Alvin Langdon Coburn and the mid-twentieth century photographer Art Sinsabaugh explored ways to translate wide, plunging spaces from three-dimensional reality into the two-dimensional picture plane. During the 1860s, Carlton Watkins celebrated the newly built railway lines, while contemporary photographer Mark Ruwedel reminds us of the tremendous transformations of terrain involved in constructing the railroads. Nineteenth-century maritime views by Roger Fenton and Gustave Le Gray, which we sequenced with twentieth-century ones by Kenneth Josephson and Hans Aarsman, make evident the evolving conceptual approaches of photographers over the course of their medium's history. By alluding to man's place in relation to the vast natural world, two of Hiroshi Sugimoto's long exposures from the 1990s – the misty *North Pacific Ocean, Mt. Tamalpais* and the nocturnal *Ionian Sea, Santa Cesarea III* – also illustrate that by focusing on the specific, one can sometimes suggest the universal.

Some of the most extraordinary pictures in the Collection fall loosely into the category of social documentary and street photography (again, with a very American bent) and it was a great pleasure to be able to include a number of them here. From Lewis Hine's famous turn-of-the-century image of a young girl working in a Carolina cotton mill to Gordon Parks's Harlem gang member patrolling the neighbourhood streets on his bicycle, many of these photographs were originally made for reproduction in publications, whether grainy pictures in mass-produced tracts on child labour abuses or the glossy pages of *Life* magazine. By the 1930s and '40s, more and more photographers were also taking up the new handheld 35mm cameras, which allowed them to work candidly and spontaneously, sometimes without their subject's knowledge. A few, like Helen Levitt, employed right-angle viewfinders or false lenses, which may have helped in taking her image of a freewheeling group of children caught up in their imaginary play on a tenement stoop. Robert Frank and William Klein were among the most radical street photographers during the 1950s and the gritty, hit-and-run style they employed – to pick out fleeting faces in the street or on a crowded trolley – was a major influence on future generations of camera artists. Their contemporaries Bruce Davidson and Roy DeCarava, on the other hand, were typically more sensitive and circumspect in their approach to their subjects, many of whom were inhabitants of the poorest and most dangerous streets in New York.

Probably the most unexpected aspect of this world-class collection is the large number of highly abstract and Surrealist-inspired photographs that it contains. Corporate collections are not often known for acquiring challenging works of art, so we were delighted to discover a fascinating trove of images that were thought-provoking and surprisingly edgy, at times tinged with humour. Chicago photographer Jeanne Dunning's work, for example, centres on issues of gender and sexuality and her wonderful anti-self-portrait focuses not on her face, but on the strangely phallic form of the back of her head and neck. Michael Spano's inventive use of differential focus manages to make a plate of peaches appear to magically float in space, and the Czech modernist Jaromír Funke, active from the 1920s, created a glowing abstraction out of not much more than a small glass cube and a powerful ray of light. For contemporary photographer Elspeth Diederix the visual conjuring is all sleight-of-hand, rather than being digitally manipulated – from the bizarre puff of smoke to the low-flying airplane – and she prides herself on not needing Photoshop to create her surreal dreamscapes. Often too there are obvious art historical references that appealed to us: for example, mysterious fragments of early Netherlandish paintings show up in an image by Dutch photographer Henze Boekhout, and the ephemeral beauty of Laura Letinsky's table-top assemblages hark back to *vanitas* imagery in seventeenth-century still lifes.

In the process of organising this exhibition, we also found fascinating connections among some of the technically experimental photographs in the collection. For instance, Vik Muniz's *Mass,* from his series *Pictures of Chocolate,* and Félix Gonzáles-Torres's *Untitled (Sand)* are both metaphorical images of crowds made by means of ephemeral materials. The Brazilian-born Muniz, who lives in New York, alludes to mass culture in his image of a crowd drawn with Bosco chocolate syrup, and the Cuban-born, Puerto Rico-raised Gonzáles-Torres, who also lived – until his early death – in New York, represents the large number of fellow sufferers from AIDS in his eight-part sequence of footprints in the sand (printed in photogravure, a process that in itself makes reference to mass reproduction).

In another context, Abelardo Morell and Vera Lutter use the camera obscura to explore, in complementary ways, the mysterious simplicity of the basic photographic process. Each working with a room-size camera – produced by darkening all windows except for a tiny aperture through which the outside world is projected upside-down on the opposite wall – they provide a contemporary update of this antiquated practice. In *135 LaSalle Street, Chicago, VI,* a depiction of the headquarters of the former LaSalle Bank (later acquired by Bank of America), Lutter inverted the image so it would appear in its correct right-side-up orientation, emphasising the stark, ethereal geometry of the urban landscape. In his camera obscura image, Morell creates a dramatic, topsy-turvy effect by overlaying the outside world across furnishings in his home. Other innovative approaches to architecture include Toshio Shibata's photograph of a large-scale public works project, in which he discovers subtle beauty in the incongruous juxtapositions of the natural and man-made worlds, and Stéphane Couturier's documentation of a construction site on the famous Unter den Linden, in Berlin, in which pattern and colour infuse his view with poetry and lyricism.

For curators, the opportunity to delve into another collection in this way, to explore its breadth and discover its strengths, is a rare treat. We felt a bit like kids in a candy shop, surrounded by abundance. Bank of America's staff members were terrific collaborators throughout the process, encouraging at every step. Anyone else surveying the company's impressive photography holdings would have come up with a very different exhibition, but this presentation grew out of our personal preferences, different areas of expertise and the collections we curate here at the MFA, Boston. The result is a show of more than one hundred works – both famous and little known – that we hope will inspire conversations among those who see it that are as exciting and thought-provoking as the ones we shared while organising it.

ANNE HAVINGA,
SENIOR CURATOR OF PHOTOGRAPHS
KAREN HAAS,
CURATOR OF PHOTOGRAPHS
MUSEUM OF FINE ARTS, BOSTON

Candida Höfer
Museo Civico Vicenza II,
1988

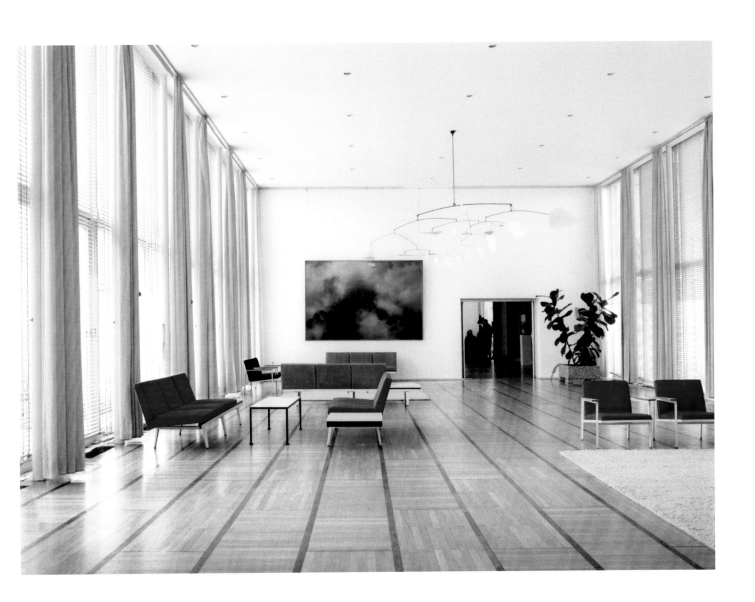

Thomas Ruff
d.p.b. 08, 2000

Richard Misrach
Pyramids with Ticket Booth, Egypt,
1989

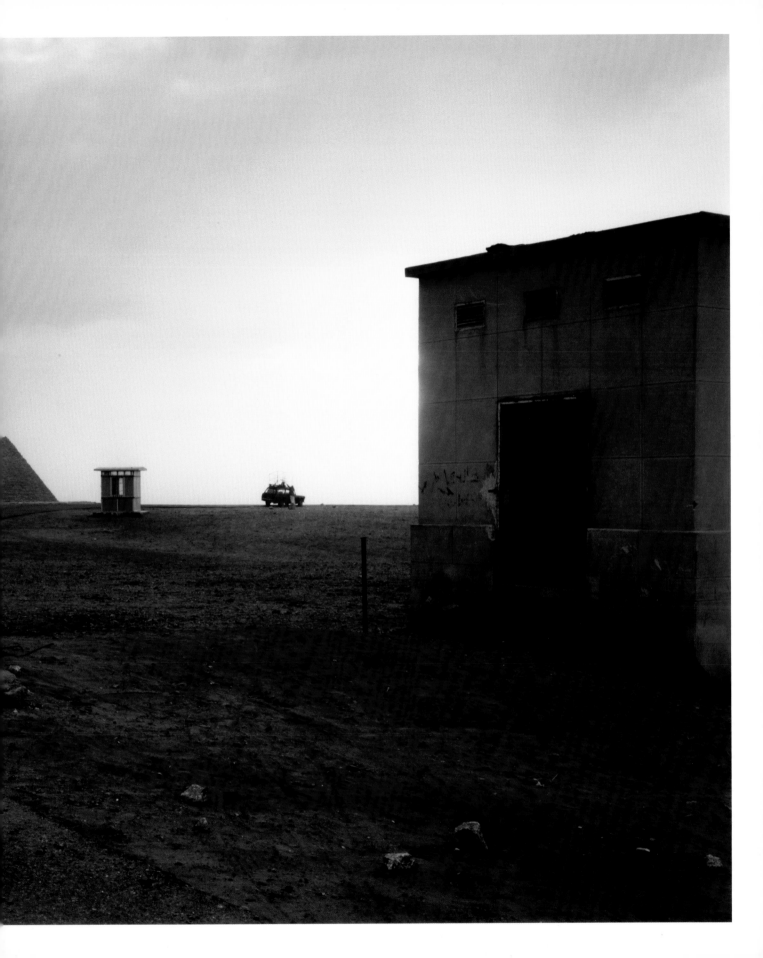

Félix Teynard
*Gournah (Thebes), Colosse
de Gauche – Decoration de
la Face Norde-Est du Trone,
1851–52*

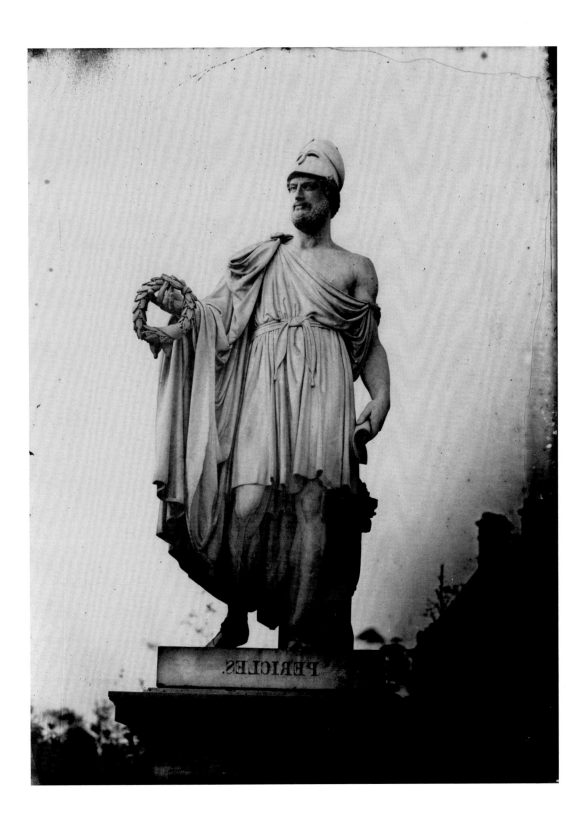

Francis Frith
The Ramesseum of El-Kurneh,
Thebes, Second View, 1857

Joe Rosenthal
Flag Raising at Iwo Jima,
1945

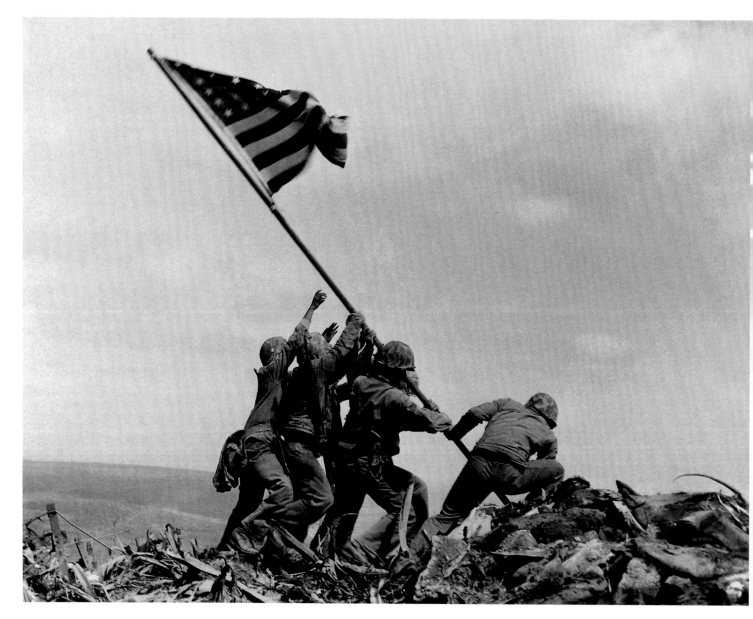

Luc Delahaye
Taliban Surrender, 2001

Robert Louis Frank
Trolley – New Orleans,
Louisiana, 1955

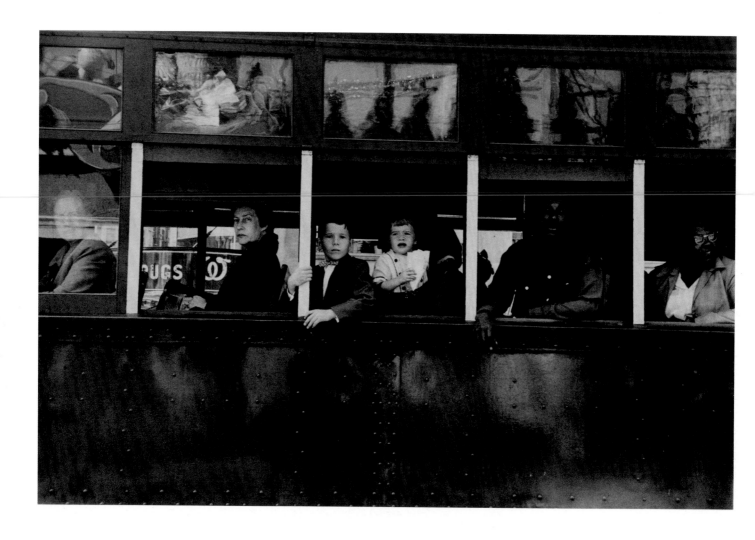

Garry Winogrand
World's Fair, New York City,
1964

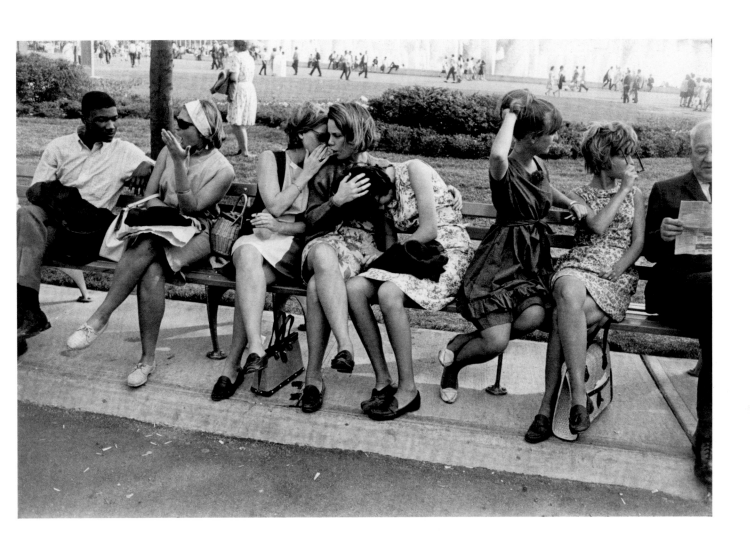

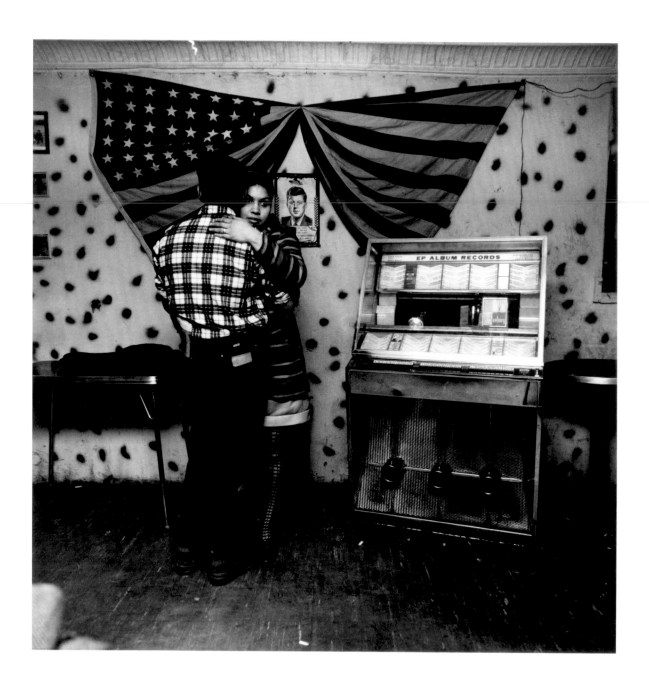

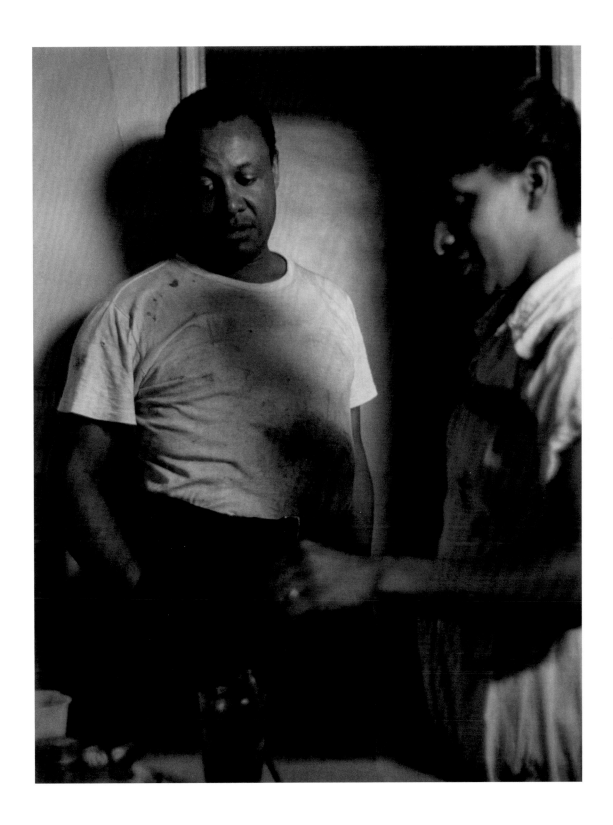

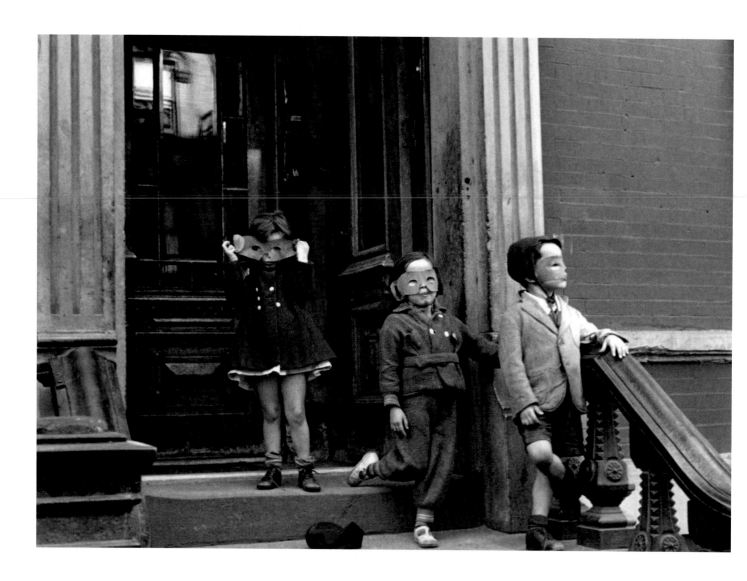

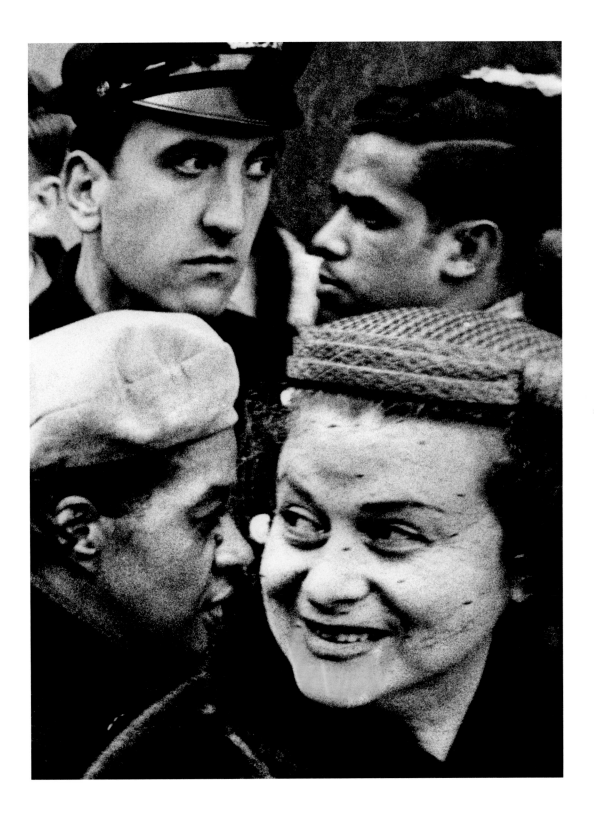

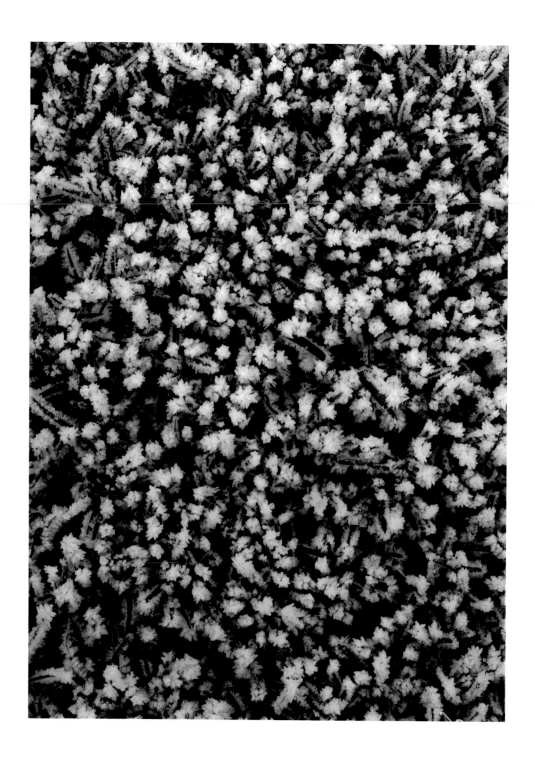

Toni Schneiders
Weichen (Switches), 1954

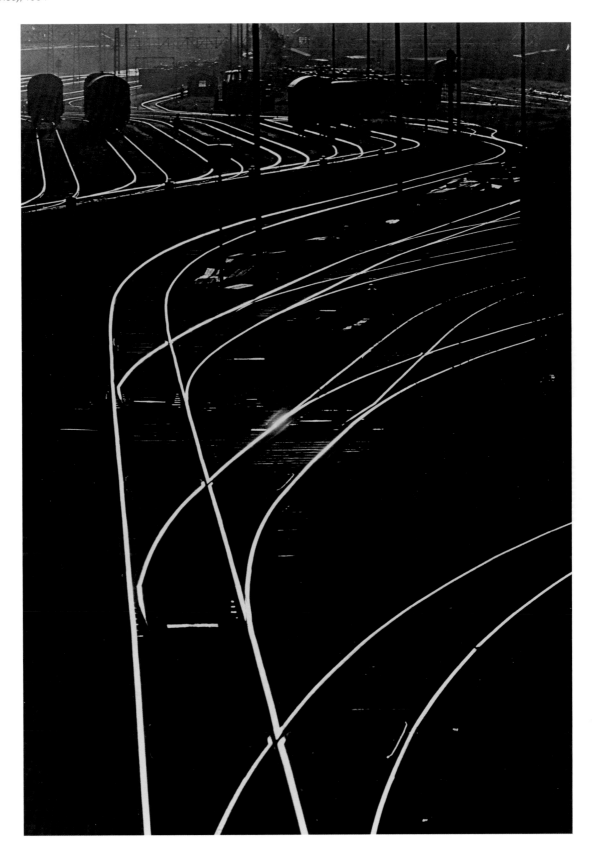

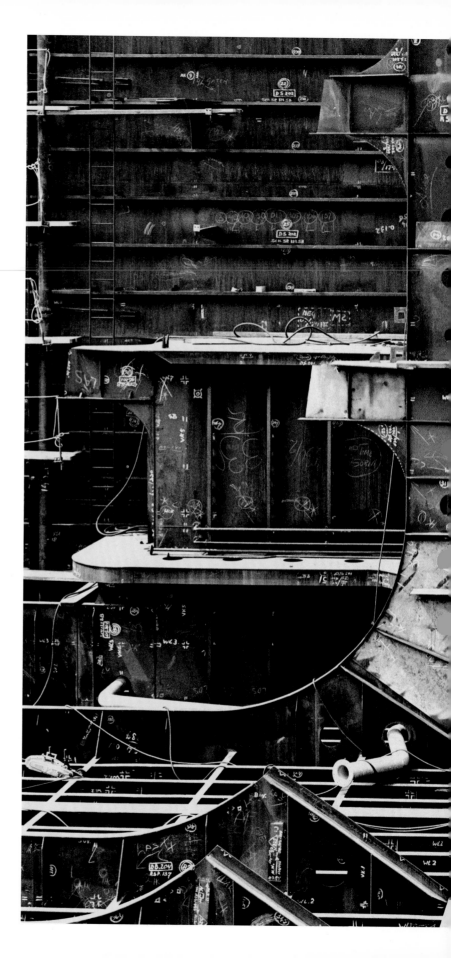

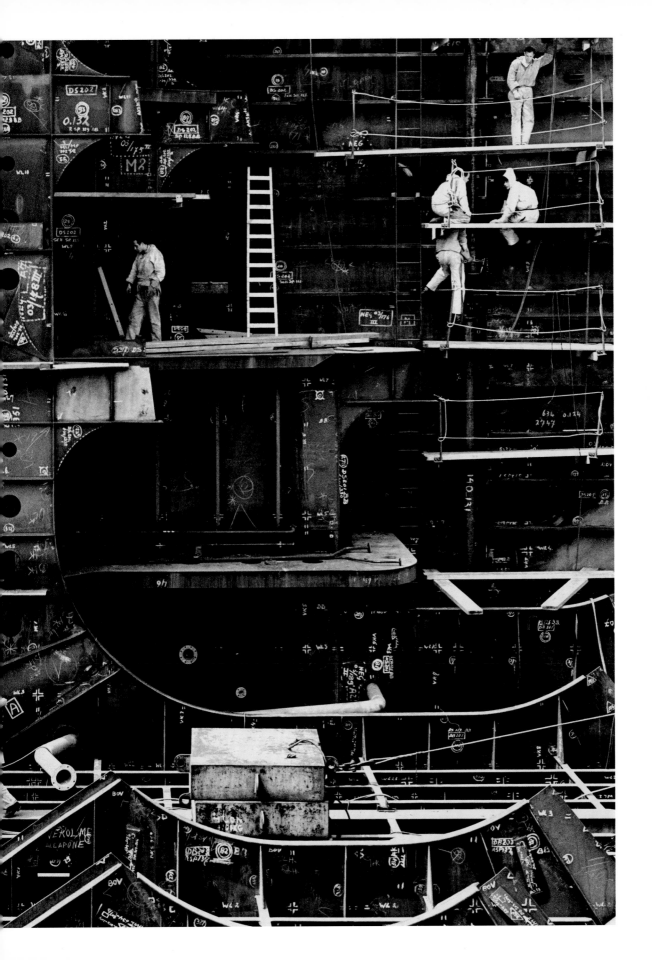

Vera Lutter
135 La Salle Street, Chicago, VI,
November 16, 2001

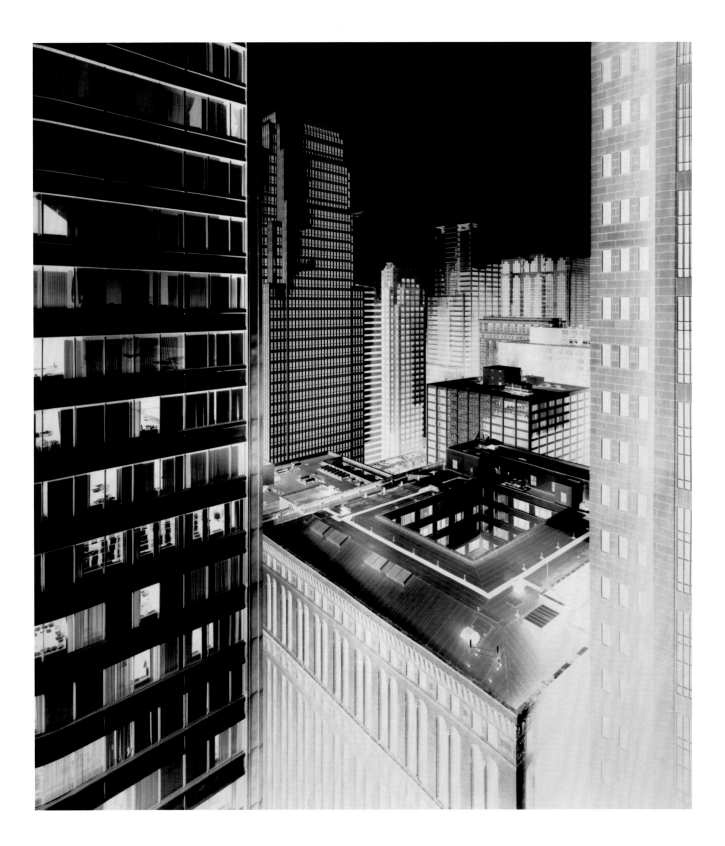

Ed Ruscha
*Parking Lots #290 (Rocketdyne,
Canoga Park),* 1967

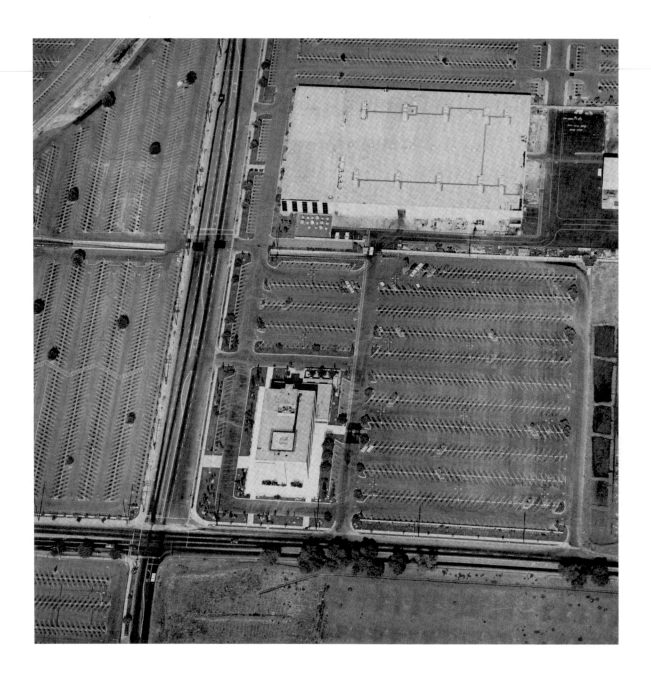

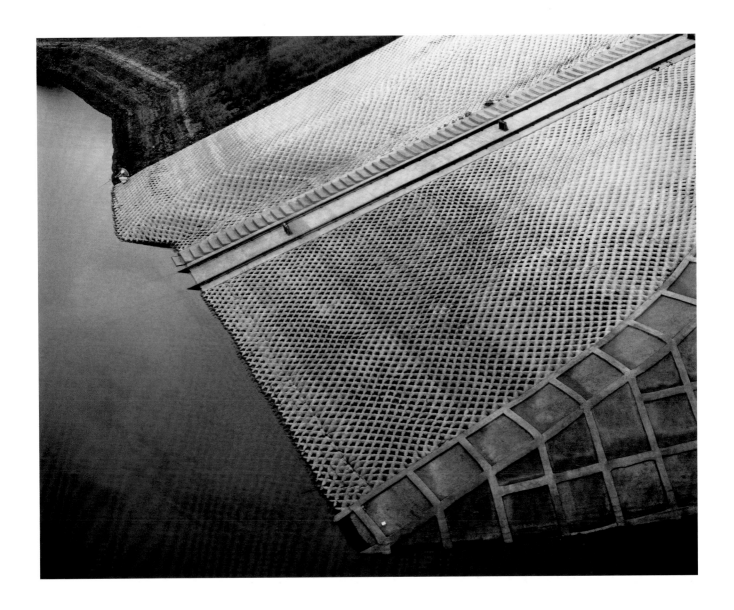

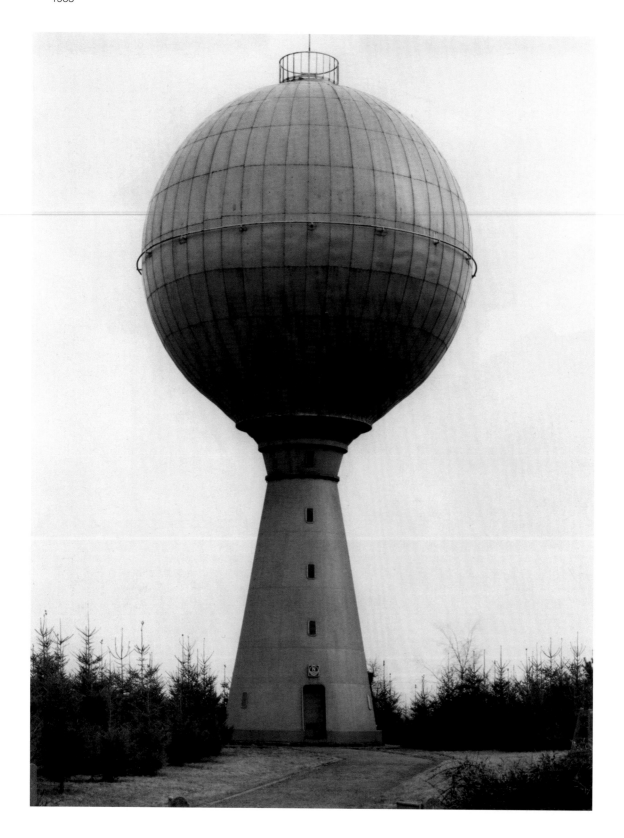

Bechers and Beyond

The exhibition, which presents a selection of photographs from the Bank of America Collection, sheds light on the history and development of the medium from the 1850s to the present day. The photographs that I will discuss in this text, however, are from the Düsseldorf School of Photography, which emerged between 1976 and 1997 at the Kunstakademie Düsseldorf. The term has become synonymous primarily with photographers who studied under Bernd and Hilla Becher – such as Thomas Struth, Andreas Gursky, Thomas Ruff and Candida Höfer. This school was not only important within Germany, but has also had a wider impact on contemporary photography in general. This essay will trace the photographic movements that influenced the Bechers and ultimately informed their students. The photographic language that has emerged from the Bechers' school not only has its own distinctive aesthetic, but also engages with contemporary artistic discourse. It addresses the viewer, engages in institutional critique (and with the idea of creating an archive) and provides a conceptual framework in which photography can be understood. Their teaching encouraged what could be called a 'rigorous continuity' in the treatment of subjects – a concept best exemplified in their own series of photographs documenting a single type of building (such as water towers) using the same perspective and lighting, a technique that highlighted the formal continuities between the various buildings. They also encouraged the use of display formats that would highlight this continuity (as the Bechers themselves achieved in their famous grid style of displaying images). The social and political connotations of the Bechers' work is also significant – it not only provides an archive of key developments in the period in which it was created, but also offers a commentary on our globalised society.

To understand the development of the Düsseldorf School that emerged under the influence of the Bechers' teaching, one has to trace the Bechers' own photographic influences. Their photography was a return to the 'straight' aesthetics of photographers associated with the New Objectivity movement and to the social and political preoccupations of photographers working in the 1920s and the 1930s.

In a response to the New Objectivity aesthetic in Germany, a subjectivist photography emerged that became popular in the early post-war period. The Subjektive Fotografie movement was founded by Dr. Otto Steinert, who defined it as 'humanised and indivualised photography' whose intention was 'to capture from the individual object a picture compounding to its nature'[1] and to move away from the Modernist objectivist photography of the 1920s. However, the Bechers re-embraced the functional form of New Objectivity, rejecting the subjectivist humanist approach that was prevalent amongst their contemporaries. New Objectivity was methodological in its approach, as exemplified by August Sander's systematic photographic portraits of Germans from all classes and occupations. This methodology was adopted by the Bechers and is best seen in their typological documentation of the vernacular industrialised architecture of Western Europe and North America. This systematic approach was integral to their photographs and had an enduring influence on their students.

Objectivist photographers such as Albert Renger-Patzsch and László Moholy-Nagy shared the modernist preoccupation with progress and were strong advocates of the integration of technology and industry into the arts. They were linked to the Bauhaus School, which was founded by Walter Gropius and was the leading exponent of Modernist architecture and design. However, the objectivist approach was not universally welcomed. Walter Benjamin, whose texts such as *The Author as Producer* had an important impact on how photography was perceived, attributed the fashion of reportage to New Objectivity,[2] of which he was critical, saying 'it had succeeded in turning abject poverty itself, by handling it in a modish, technically perfect way, into an object of enjoyment'[3], citing Renger-Patzsch's well known book, *The World Is Beautiful*, as an example. Renger-Patzsch's publication, a collection of one hundred photographs of natural forms, industrial subjects and mass-produced objects presented with the clarity of scientific illustrations exemplified the movement's aesthetic. Benjamin viewed this objectification as not having a revolutionary value as it separated itself from experiencing solidarity with the proletariat. The 1920s and 1930s saw the use of photography as a powerful tool of political propaganda, a development that led to suspicion and criticism of it as a genuine pictorial form.

The political aspect of New Objectivity is not what interested the Bechers; it was the formal and aesthetic continuity among the images they created that was paramount to their approach. The pattern of sequential experience that connected one image to the next was reflected in how they exhibited their photographs – the works were not displayed in isolation but in blocks that created a relationship between the constituent parts of each photograph. By grouping the photographs together, the uniformity of the objects is revealed. The series on water towers featured in the *Conversations* exhibition (*Water Tower, Verviers, Belgium,* 1983 and *Water Tower, Trier-Ehrang, Germany*, 1982) demonstrates this uniformity – not only of the objects themselves but also of the photographs' central perspective. Both photographs are shot in black and white; the water towers in each are shot using central perspective and are in the foreground. The surrounding landscape is desolate and devoid of any human activity. Although both images highlight the formal uniformity of the water towers, the periods in which they were built differ: the Verviers water tower is a feat of modern engineering, whilst the Trier-Ehrang tower has a more archaic form.

The Bechers' photographs are often characterised as "industrial archaeology" or seen as "a contribution to the social history of industrial work". However, the Bechers reject this functionalist classification of their photographs and refer to them instead as "anonymous sculptures" or "basic forms", highlighting the aesthetic aspect of their work. They use a conceptual framework when discussing their work, viewing photography as a framing or recording device for the Duchampian 'found' image in the world.[4] When photographing the structures, the Bechers ensure that there is a consistency in their framing, centrally locating the viewpoint and creating uniform lighting in each photograph. The format of each photograph is also repeated. The buildings or objects are in the forefront and are sharply focused, leaving the other details or human elements to fade in the background, allowing the viewer to focus on the subject. There is a 'democratic' approach to the display

of the images, in that no photograph is given precedence over another. The singularity of this approach had a strong influence on their students at the Kunstakademie Düsseldorf.

A central perspective, regulating the viewer's response to the image, initially determined Thomas Struth's vision. There is a similar strategy for each series that he pursues, clearly demonstrating the influence of the Bechers. The repetition of motifs throughout his work gives his sequences the essence of an archive. Struth's earlier work concentrated on postwar urban reconstructions; the street squares, residential towers and transportation hubs serve as a commentary on the social devastation of the National Socialist period in Germany, the pieces' aesthetic reflecting on the politics of that era and the state of mind of its inhabitants. Remarkably, Struth highlighted the desolation of this period through the documentation of its public spaces, which, in the photographs, are devoid of a public.

Also included in the Bank of America Collection is Struth's *Musée du Louvre, Paris*, 1989, which shows a museum audience viewing Théodore Géricault's *The Raft of the Medusa*. The viewers echo the composition of the shipwrecked figures on the raft, thereby becoming an extension of the painting itself. There is an irony in how this painting has become fetishised despite the fact that it depicts desperate survivors about to resort to cannibalism. Struth incorporates the painting's very traditional art historical subject matter and dramatic composition into his own work, his intention in the museum series being to "retrieve masterpieces from the fate of fame, to recover them from their status as iconic paintings, to remind us that these were works which were created in a contemporary moment, by artists who had everyday lives."[5] *Audience 4*, 2004, shows a view of the interior of Florence's Galleria dell' Accademia, where a museum audience gathers to view Michelangelo's *David*. The statue itself is out of view, but the facial expressions captured by Struth offer a meditation on the dividing line between awareness and actual seeing. The photographs act as a document of the viewers' response to works encountered. What separates his work from the objective approach in this series is the fact that "he must repeatedly train

his view camera on the same configuration of space. In the authorial role that he adopts, as opposed to the 'objective' tradition, his selection process lays emphasis on the photographic construction of reality; the above mentioned ideal is identifiable as an aesthetic product while at the same time it reflects the social attitudes towards art."[6] Struth has reversed the role of subject and object in this series – as viewers we are presented with a construct that illustrates not only the social dynamics of public spaces, but also how society responds to a work of art.

The monumental scale of the photographic works is consistent throughout this series, and replicates somewhat the scale of the paintings that the viewer beholds. One could view this as a means to posit photography within the same realm as painting, which had previously dominated museums and public institutions. This monumentality is also found in the works of Andreas Gursky. Both photographers have addressed themes that could be described as post-urban, and the repetition of motifs within their work is typical of the Düsseldorf School. Gursky, like Struth, has used as his subject matter paintings and the interiors of museums, such as his piece *Untitled VI*, 1997, a documentation of Jackson Pollock's painting in MoMA, New York. What distinguishes Gursky is that he was one of the first photographers to employ digital technology to create his imagery. This manipulation of images, which is now commonplace, was revolutionary in the way it altered our perception of photographs. Images can now be made with composites or made from scratch through digital media. The piece in the exhibition entitled *Centre Georges Pompidou*, 1995, a panoramic image of the interior of the museum, is an example of Gursky's digital streamlining. In it we see a scattered audience bent over trestle tables that provide a platform for the exhibition of the plans and models of the Swiss architects Herzog & de Meuron. Gursky plays with scale and structure to obscure the subject of the exhibition. Here, the grid-like structure of the minimalist interior of the building and the trestle tables recalls minimalist paintings and Modernist architecture.

Thomas Ruff was also one of the first photographers to use digital techniques, beginning in 1989 to excise

unwanted distractions from his pictures of buildings.[7] In 1998, Ruff was invited by Julian Heynen of the Kunstmuseum Krefeld to document villas by architect Ludwig Mies Van der Rohe built between 1927 and 1930. However, as some of these villas could not be photographed by him, he digitally processed existing pictures of them. The resulting images are out of focus and it is difficult to decipher what the subject matter is, as can be seen in the photograph *d.p.b 08*, 2000 that is included in the catalogue. For Ruff and Gursky, the use of digital technology is consistent with the fluidity of the medium of photography and its continuing mutation in the digital age. Photography has become an essential part of how our perception of reality is mediated. As consumers of images, the general populace is quite sophisticated in terms of how such pictures are deconstructed. Today, we approach images with a heightened scepticism, and an unquestioned link between photography and truth is no longer assumed.

Candida Höfer's work runs counter to this movement towards digital manipulation, in that her photographs are direct documentations of the interiors of public buildings. The photographs are naturally lit and although the composition is not centrally located, there is a consistency in her aesthetic and formal approach. Two of her photographs are included in the *Conversations* exhibition. *Museo Civico Vicenza II*, 1988, which is part of her museum series, documents an exhibition space within the museum that is devoid of a public. It reveals the classical nature of the interior architecture, a feature that is often obscured by the paintings exhibited in the space. There is a painterly quality to the piece. The natural light from the windows is reflected on the polished floor and strikes a painting. *Museum Folkwang Essen*, 1982 documents the interior of a museum that is quite modernist in its layout and its furnishings, in contrast to the classical interior of the *Museo Civico Vicenza*. The photographs act as an architectural archive as well as a social archive of locations of public interaction. The importance of these spaces to public life is highlighted by the historical significance of the architecture of the museums – in addition to their function as purveyors of cultural history and knowledge. Höfer's photographs move beyond the documentary approach

and are indicative of what has been called 'post-documentary', a term which both Struth and Gursky have also been associated with.

While these photographers are generally associated with the Düsseldorf School, they also have their own, very individual, framework. For example, they have moved away from established notions of mechanical reproduction and rejected strict parameters in terms of consistency in lighting or perspective. And with the advent of digitisation, all limitations on photography have been removed. What truly sets these photographers apart is their use of large-format photography, a development that began in the 1980s and persists to this day. These large-format photographs are frequently seen in museums and public arenas and are made specifically for this purpose.

The importance of the photographers that followed in the Bechers' wake is that they have become the archivists of Western capitalism and its technological developments. The photographs are a record of a time that also will pass – as with the work of the Bechers, whose photographs documented post-industrial decay. The photographs of contemporary cityscapes, architecture and technological progress will also look archaic to a future audience. They will become the subject of nostalgic reminiscences of a time that has passed, a document of the pinnacle of late capitalism and its ultimate collapse. These photographs will become signifiers of a historical moment. The empty glass towers, apartment blocks and deserted estates that have become part of our everyday experience will become the ruins of the future. These photographs are inherently political in that they provide the beholder with a means to be one step removed and have an objective view of the spaces we inhabit on macro and micro scales, allowing us to sense our own historical relevance in a contemporary moment.

MARY CREMIN
PROJECT CURATOR: EXHIBITIONS
IRISH MUSEUM OF MODERN ART

[1] As quoted by Allan Porter in "Subjective Photography 4", *Camera*, July 1975: p.5.
[2] Walter Benjamin, "The Author as Producer", in *Art in Theory 1900–2000*, edited by Charles Harrison & Paul Wood, (Oxford: Blackwell Publishing, 2003) p.496.
[3] ibid.
[4] Edward Welch, Andrea Noble, JJ long (eds), *Photography: Theoretical snapshots*, (New York: Routledge, 2009) p.101.
[5] Annette Kruszynski Tobia Bezzola and James Lingwood (eds), *Thomas Struth*, (New York: Monacelli Press, 2010) p.198.
[6] Stefan Gronent, *The Düsseldorf School of Photography*, (London: Thames & Hudson, 2009) p.37.
[7] Peter Galassi, *Andreas Gursky*, (New York: The Museum Of Modern Art, 2001) p.39.

Bernd and Hilla Becher
Water Tower, Trier-Ehrang, Germany,
1982

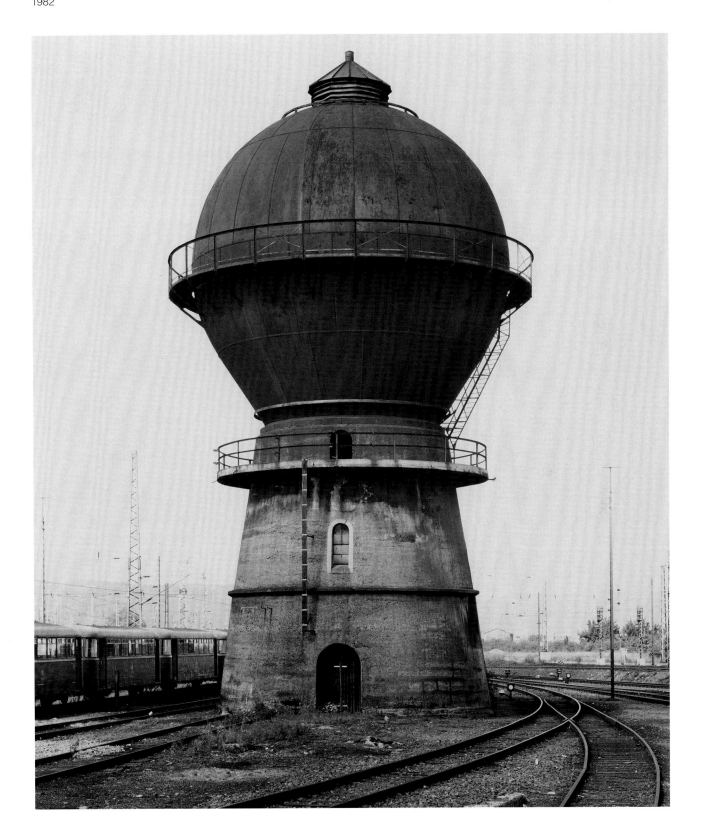

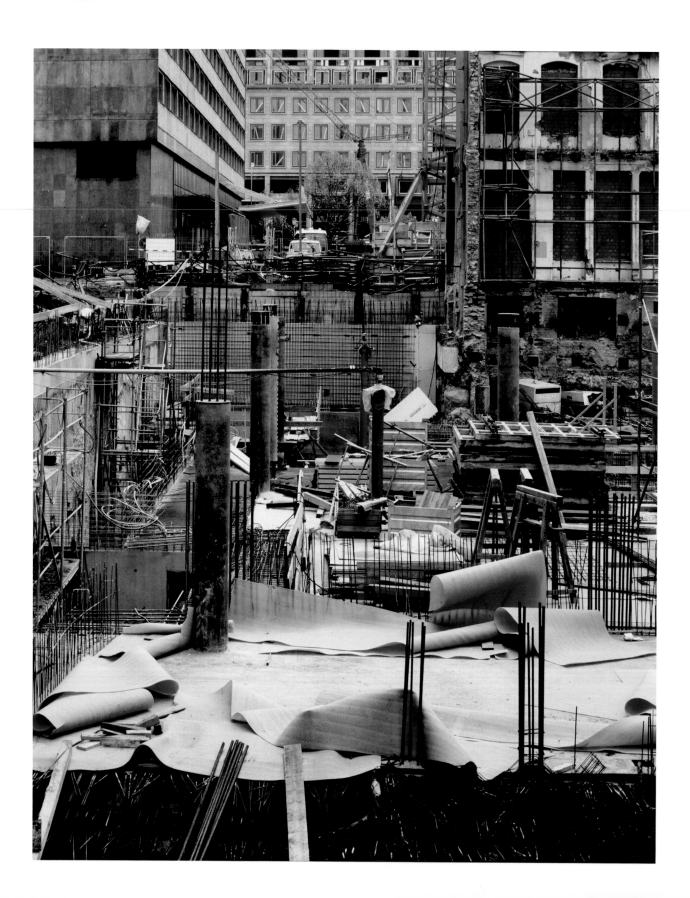

Thomas Struth
Giulia Zorzetti vor einem Bild
von Francesco di Mura, Chiesa
Donna, Romita, Napoli, 1989

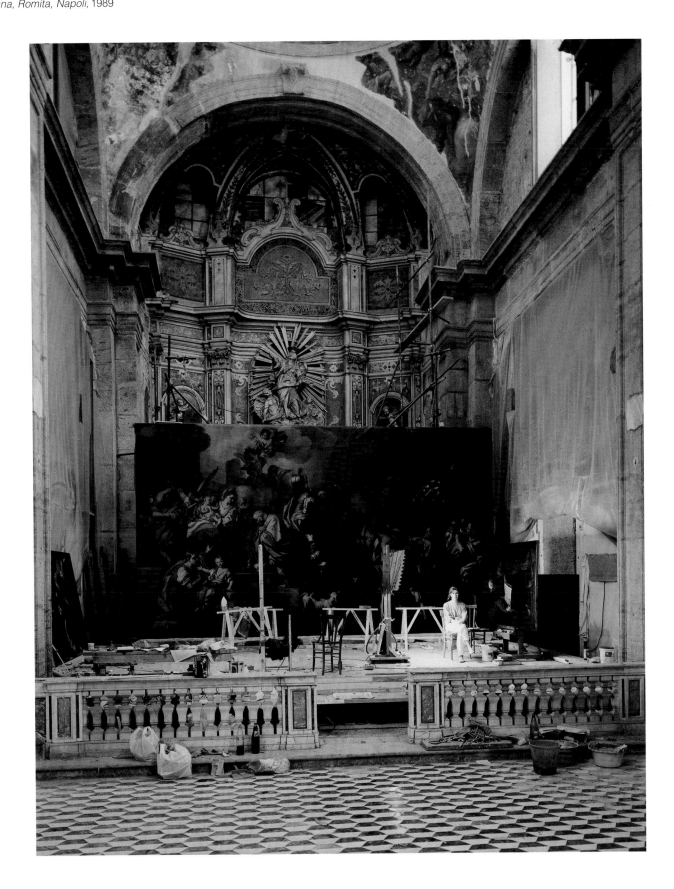

Tseng Kwong Chi
Niagara Falls, New York,
1984

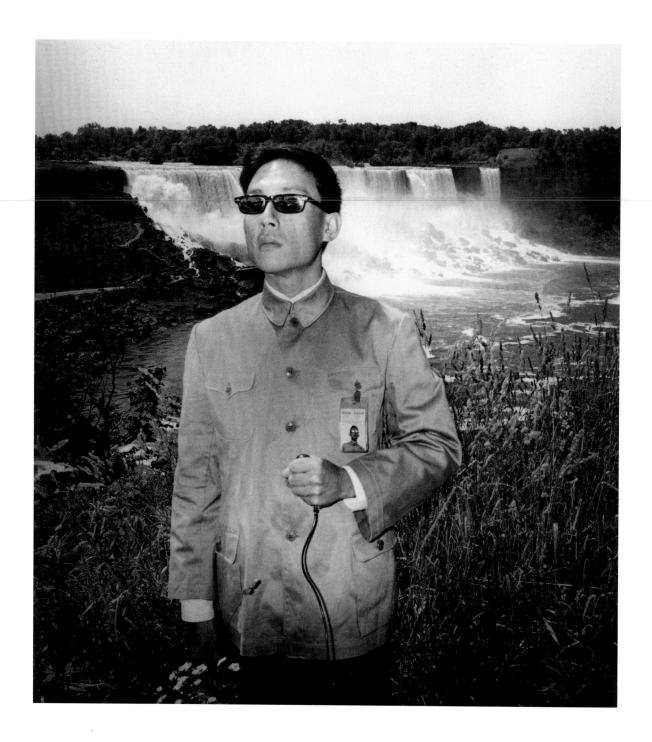

Gordon Parks
*"Brother" Price, Red's Cousin
and Assistant Gang Leader,
Harlem, NY,* 1948

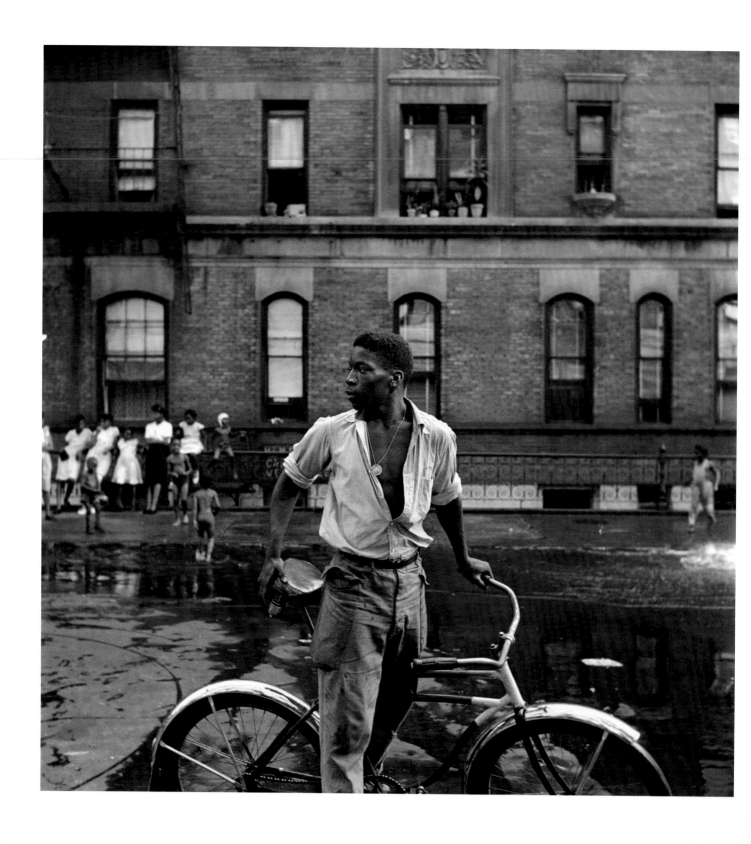

Dorothea Lange
Damaged Child, Shacktown,
Elm Grove, Oklahoma, 1939

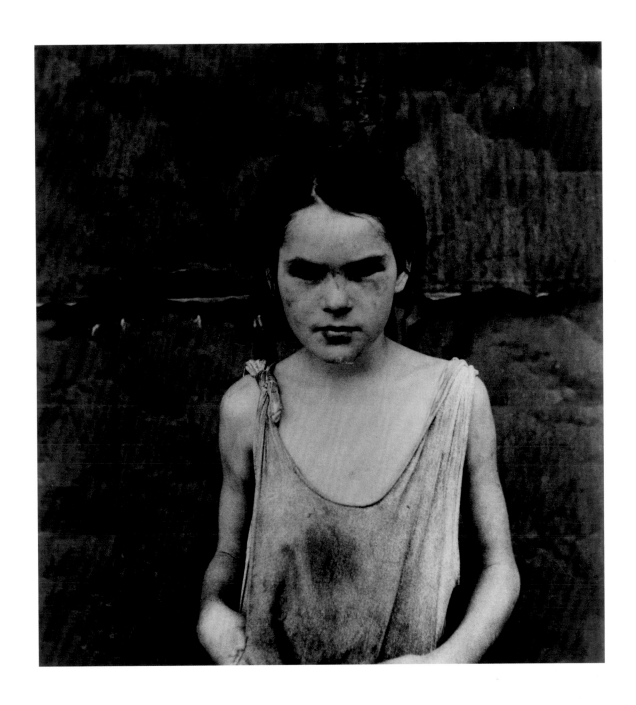

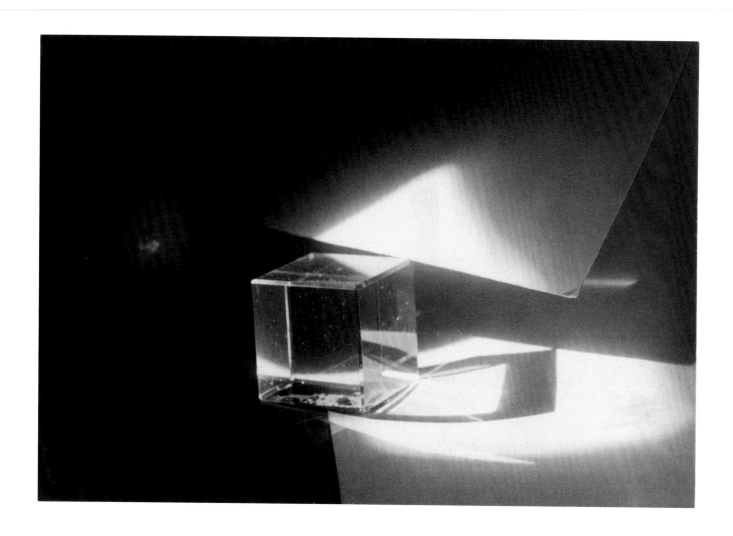

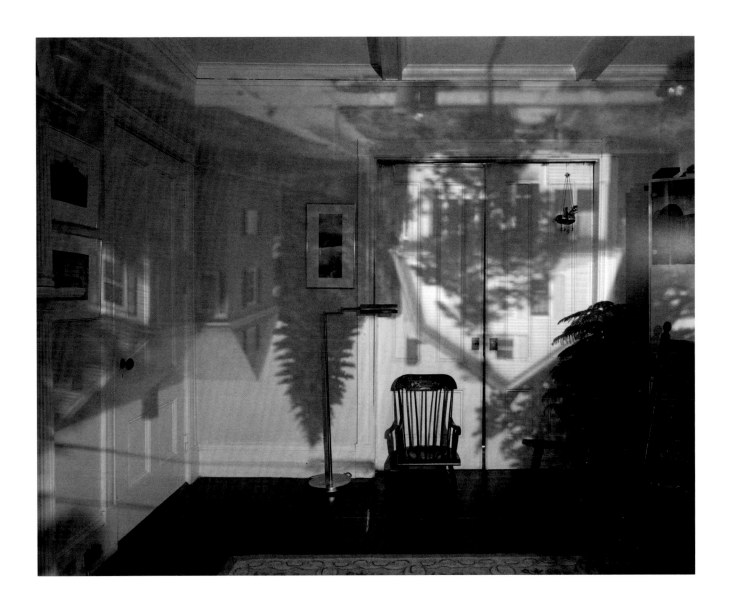

László Moholy-Nagy
Light Space Modulator, c.1930

Michael Spano
Four Peaches, 1997

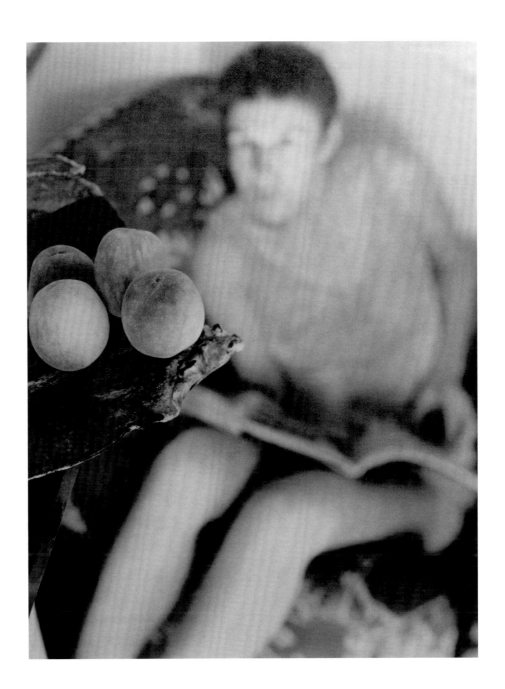

Dr. John Murray
*Taj Mahal, The Mausoleum
from Rest-House,* c.1858-62

Checklist to the exhibition

74 Hans Aarsman
Launching, Waterhuizen, 1988
Dye coupler print
68 x 100 cm
Courtesy the artist

77 Anonymous American Photographer
The Two Scouts,
1860s-70s
Whole-plate tintype
49.84 x 39.68 cm

117 Eugène Auguste Atget
Tuileries-Promethee par Pradier, 1911
Aristotype
20.32 x 17.78 cm

52 Theo Baart
Hoofdweg, 1997
Dye coupler print
58.4 x 48.3 cm
Ooms, Hoofdweg,
Hoofddorp, 1997
by Theo Baart

41 Tina Barney
Father & Sons, 1996
Colour coupler print
121.9 x 152.4 cm
© Tina Barney. Courtesy
Janet Borden, Inc.

66 Uta Barth
Field #5. 1995
Colour photograph on panel
58.4 x 73 cm
Courtesy the artist and
Tanya Bonakdar Gallery,
New York

134 Bernd and Hilla Becher
Water Towers, Verviers, Belgium, 1983
Gelatin silver print
60.9 x 50.8 cm
© Sonnabend Gallery,
New York

141 Bernd and Hilla Becher
*Water Tower,
Trier-Ehrang, Germany,*
1982
Gelatin silver print
60.9 x 50.8 cm
© Sonnabend Gallery,
New York

72 Henze Boekhout
Untitled, 1987
Gelatin silver print
36.2 x 47 cm

10 Harry Callahan
Chicago, 1960
Gelatin silver print
25.4 x 20.3 cm
© The Estate of Harry
Callahan, Courtesy
Pace/MacGill Gallery,
New York

27 Julia Margaret Cameron
Untitled (Mary Emily 'May' Prinsep), 1870
Albumen silver print
58.4 x 46.4 cm

144 Tseng Kwong Chi
Niagara Falls, New York,
1984
From the Expeditionary
Self-Portrait Series
1979–1989
Gelatin silver print
33.3 x 32.4 cm
© 1984 Muna Tseng
Dance Projects, Inc.
New York

70 Alvin Langdon Coburn
Snow in Canyon, Grand Canyon, 1911
Platinum print
33.02 x 27.9 cm

142 Stéphane Couturier
Under den Linden, Berlin, 1996
Cibachrome
101.6 x 127 cm
© Stéphane Couturier

92 Gregory Crewdson
*Untitled (*from *Natural Wonder Series),* 1992
Chromogenic print
68.6 x 88.9 cm
© Gregory Crewdson.
Courtesy Gagosian
Gallery

122 Bruce Davidson
Couple Dancing Near Juke Box with Flag and JFK, 1966-68
Gelatin silver print
68.6 x 88.9 cm
© Bruce Davidson /
Magnum Photos

123 Roy DeCarava
Sam and Shirley, talking,
1952
Gelatin silver print
33.7 x 22.9 cm
© Sherry Turner
DeCarava. Courtesy
The DeCarava Archives
2011

118 Luc Delahaye
Taliban Surrender, 2001
Colour coupler print
111 x 237.5 cm
Courtesy Galerie
Nathalie Obadia Paris/
Bruxelles

44 Philip-Lorca diCorcia
Mario, 1978
Ektacolor print
50.8 x 61 cm
Courtesy the artist and
David Zwirner, New York

34 Elspeth Diederix
Air, 1999
Dye coupler print
73 x 100.3 cm
© Elspeth Diederix.
Courtesy Galerie Diana
Stigter, Amsterdam

12 Mike Disfarmer
Untitled (Willie Dettweiler, Vernon Higgs, Heber Springs, Arkansas), 1946
Gelatin silver contact print
12.7 x 7.9 cm
© Courtesy Edwynn
Houk Gallery, New York.
© www.disfarmer.com

2 Jeanne Dunning
Neck, 1990
Silver dye bleach
facemounted on
plexiglas
83. 5 x 70. 9 cm
© Donald Young Gallery
& artist

49 William Eggleston
Untitled (Memphis),
c.1970
Dye transfer print
51.4 x 61.6 cm
© Eggleston Artistic
Trust. Courtesy Cheim
& Read, New York

39 Mitch Epstein
Dad's Briefcase, 2003
Colour coupler print
56.5 x 71.1 cm
© Mitch Epstein.
Courtesy of the Artist
and Yancey Richardson
Gallery

20 Walker Evans
Penny Picture Display, Savannah, 1936
Gelatin silver print
45.7 x 35.6 cm
© Walker Evans Archive,
The Metropolitan
Museum of Art

76 Roger Fenton
Cossack Bay, Balaklava,
1855
Salt print
46.4 x 57.1 cm

145 Gerrit Petrus Fieret
Untitled, 1960s
Gelatin silver print
with marker and hand
stamping
39.7 x 49.8 cm
© 2011, the Estate of
Gerard P. Fieret,
Fotomuseum den
Haag/Courtesy Deborah
Bell Photographs,
New York &
Paul M. Hertzmann, Inc.,
San Francisco

120 Robert Louis Frank
*Trolley – New Orleans,
Louisiana*, 1955
Gelatin silver print
30.5 x 48.3 cm
© Robert Frank.
Courtesy Pace/MacGill,
New York

43 Lee Friedlander
*T.V. in Hotel Room,
Galax Virginia*, 1962
Gelatin silver print
14.9 x 22.2 cm
© Lee Friedlander.
Courtesy Fraenkel
Gallery, San Francisco

114 Francis Frith
*The Ramesseum of
El-Kurneh, Thebes,
Second View*, 1857
Albumen silver print
38.7 x 47.6 cm

148 Jaromír Funcke
Light Abstraction,
1924-25
Gelatin silver print
14.9 x 21.6 cm

48 Ben Gest
Chuck, Alice and Dale,
2003
Inkjet print
100.6 x 101.9 cm
© Ben Gest. Courtesy of
Stephen Daiter Gallery
and the Artist.

88 Laura Gilpin
Indian Oven, Taos, 1926
Platinum print
21.9 x 17.1 cm
© 1979 Amon Carter Museum of American Art,
Fort Worth, Texas, gift of
the Artist, P1979.95.29

103 Felix Gonzalez-Torres
'Untitled' (Sand),
1993-94
8 photogravures
31.8 x 39.4 cm
© The Felix Gonzalez-Torres Foundation.
Courtesy of the Andrea
Rosen Gallery, New York

64 Rodney Graham
Welsh Oak (#4), 1998
Gelatin silver print
121.9 x 91.4 cm
© Courtesy Donald
Young Gallery, Chicago

78 Gustave Le Gray
*Seascape with Sailing
Ship and Tugboat,
Normandy, c.*1857
Albumen print
57.5 x 67.6 cm

86 Jan Groover
Untitled, 1978
Colour coupler print
60.3 x 71.8 cm
© Jan Groover. Courtesy
Janet Borden Inc.

90 Andreas Gursky
*Centre Georges
Pompidou*, 1995
Colour coupler print
56.2 x 72.1 cm
© Andreas Gursky, VG
BILD-KUNST, Bonn.

38 David Hilliard
Dad, 1998
Colour coupler triptych
60.9 x 50.8 cm
© David Hilliard,
Courtesy of the Artist
and Yancey Richardson
Gallery

24 Lewis Wickes Hine
Child Labour, c. 1908
Gelatin Silver Print
38.1 x 35.6 cm

107 Candida Höfer
Museo Civico Vicenza II,
1988
Colour coupler print
35.6 x 53.3 cm
© Sonnabend Gallery,
New York

6 Candida Höfer
*Museum Folkwang
Essen*, 1982
Colour coupler print
38.1 x 55.8 cm
© Sonnabend Gallery,
New York

82 Graciela Iturbide
El Sacrificio, 1992
Gelatin silver print
50.1 x 40.3 cm
© Graciela Iturbide.

73 Kenneth Josephson
New York State, 1970
Gelatin silver print
20.32 x 25.4 cm
© Kenneth
Josephson/Higher
Pictures. Courtesy
Stephen Daiter Gallery,
Chicago & Gitterman
Gallery, New York

128 Aart Klein
*Ship Building, Verolome,
Botlek*, 1962
Gelatin silver print
67.9 x 83.2 cm
© Aart Klein/ Nederlands
Fotomuseum

125 William Klein
4 Heads, New York, 1954
Gelatin silver print
24.5 x 19.4 cm
© William Klein, Courtesy
Howard Greenberg
Gallery

147 Dorothea Lange
*Damaged Child,
Shacktown, Elm Grove,
Oklahoma*, 1936
© The Dorothes Lange
Collection, Oakland
Museum of California,
City of Oakland. Gift of
Paul S. Taylor

35 Laura Letinsky
Untitled #49, from the
series *Morning and
Melancholia*, 2002
Colour coupler print
48.3 x 70.8 cm
© Laura Letinsky,
Courtesy of the Artist
and Yancey Richardson
Gallery

124 Helen Levitt
*New York, c.*1940
Gelatin silver print
54.9 x 44.8 cm
© Estate of Helen Levitt,
Courtesy Laurence Miller
Gallery, NY

130 Vera Lutter
*135 La Salle Street,
Chicago, VI, November
16*, 2001
Gelatin silver print
159 x 142 cm
© Vera Lutter. Courtesy
of the artist

93 **Neeta Madahar**
Sustenance 104, 2003
Iris print
88.9 x 114.3 cm
© Neeta Madahar.
Courtesy Julie Saul
Gallery, New York

61 **Rhondal McKinney**
*Riley Thompson, Lane,
Illinois:* from the series
Farm Panorama, 1985
Gelatin silver print
20.32 x 75.2 cm
© Rhondal McKinney

32 **Hellen Van Meene**
Untitled, 1997
Colour coupler print
30.2 x 30.2 cm
© Courtesy of the works
Sadie Coles HQ,
London, Yancey
Richardson gallery
New York

110 **Richard Misrach**
*Pyramids with Ticket
Booth, Egypt*, 1989
Dye coupler print
71.75 x 84.45 cm
© Richard Misrach.
Courtesy Fraenkel
Gallery, San Francisco,
Marc Selyn Fine Art,
Los Angeles, and
Pace/MacGill Gallery,
New York

67 **Richard Misrach**
Cloud No. 4, 1987–1992
Dye coupler print
124.5 x 150.2 cm
© Richard Misrach.
Courtesy Fraenkel
Gallery, San Francisco,
Marc Selyn Fine Art,
Los Angeles, and
Pace/MacGill Gallery,
New York

150 **László Moholy-Nagy**
Light Space Modulator,
c.1930
Gelatin silver print
39 x 23.3 cm
© László Moholy-Nagy
Foundation

149 **Abelardo Morell**
*Camera Obscura Image
of Houses Across the
Street in Our Livingroom*,
1991
Gelatin silver print
© Abelardo Morell.
Courtesy Bonni Benrubi
Gallery, NYC

42 **Wright Morris**
*Front Room Reflected
in Mirror, near Norfolk,
Nebraska*, 1947
Gelatin silver print
25.4 x 20.3 cm
© Collection Center for
Creative Photography,
University of Arizona
© 2003 Arizona Board of
Regents

98 **Vik Muniz**
*Mass, from the Pictures
of Chocolate*, 1997
Cibachrome prints
Diptych, 258 x 193 cm
© Vik Muniz / IVARO
(2011)

154 **Dr. John Murray**
*Taj Mahal, The
Mausoleum from
Rest-House*,
c.1858-1862
Albumen print and
waxed paper negative
66.4 x 127.3 cm

113 **Charles Nègre**
*Périclès- Jardin des
Tuileries*, 1859
Albumenised salt print
65.1 x 54.9 cm

71 **Timothy H. O'Sullivan**
*Ancient Ruins in the
Canon de Chelle, N.M.*
1873
Albumen silver print
50.8 x 40.6 cm

146 **Gordon Parks**
"Brother" Price, Red's
Cousin and Assistant
Gang Leader, Harlem,
NY, 1948
Gelatin silver print
63.8 x 53.7 cm
© The Gordon Parks
Foundation. Courtesy
The Gordon Parks
Foundation

94 **Robert Polidori**
*Salle de l'Afrique No.3,
Chateau de Versailles*,
1984
Colour coupler print
82.6 x 99.1 cm
© Robert Polidori.
Courtesy Houk Gallery

26 **Man Ray**
Portrait of Nancy Cunard,
1925
Gelatin silver print
27.9 x 21.3 cm
© Man Ray Trust

116 **Joe Rosenthal**
Flag Raising at Iwo Jima,
1945
Gelatin silver print
54.6 x 44.5 cm
© AP Photo/Joe
Rosenthal

51 **Meridel Rubenstein**
*Donaldo Valdez, El
guique, '49 Chevy from
"The Lowriders, Portraits
from New Mexico,"* 1980
Colour coupler print
35.6 x 43.2 cm
© Meridel Rubenstein

108 **Thomas Ruff**
d.p.b. 08, 2000
Colour coupler print
129.8 x 178 cm
© 2011 Artists Rights
Society (ARS), New
York/VG Bild-Kunst,
Bonn

132 **Ed Ruscha**
*Parking Lots #290
(Rocketdyne, Canoga
Park)*, 1967
Gelatin silver print
50.8 x 40 cm
© Ed Ruscha. Courtesy
Gagosian Gallery.
Photography by Art
Alanis

47 **Tomoko Sawada**
ID400 (#1-100), 1998
100 gelatin silver prints
124.5 x 99.5 cm
© Tomoko Sawada,
Courtesy of MEM Inc.

127 **Toni Schneiders**
Weichen (Switches),
1954
Gelatin silver print
40.6 x 27.9 cm
© Toni Schneiders

46 **Cindy Sherman**
Untitled Film Still #50,
1979
black and white
photograph
20.3 x 25.4 cm
Courtesy of the Artist
and Metro Pictures

133 **Toshio Shibata**
*#0139 Asahi Town,
Hokkaido*, 1988
Gelatin silver print
50.8 x 61 cm
© Toshio Shibata,
Laurence Miller Gallery

36 **Stephen Shore**
*Ginger Shore, Miami,
Florida, November 12*,
1977
Colour coupler print
30.5 x 38.4 cm
Courtesy 303 Gallery,
New York

58 Art Sinsabaugh
M.W. La #34, 1961
Gelatin silver print
7.6 x 48.3 cm
© 2004 Katherine Anne
Sinsabaugh and
Elisabeth de la Cova

56 Mike Smith
Unicoi, TN 1998
Dye coupler print
43.2 x 53.3 cm
© Mike Smith. Courtesy
of the artist

53 Alec Soth
Charles, Vasa, MN, 2002
Colour coupler print
50.8 x 40.6 cm
© Courtesy of the artist
and Weinstein Gallery

54 Jem Southam
Blue Gate, Holland, 2003
Chromogenic dye
coupler print
92.7 x 116.8 cm
© Jem Southam.
Courtesy of Charles
Isaacs Photographs and
Robert Mann Gallery,
New York

152 Michael Spano
Four Peaches, 1997
Gelatin silver print
89.5 x 69.2 cm
© Michale Spano.
Courtesy Laurence Miller
Gallery

30 Edward Steichen
*Paul Robeson as "The
Emperor Jones,"* 1933
Gelatin silver print
24.4. x 19.1 cm
Permission of the Estate
of Edward
Steichen/Courtesy
Howard Greenberg
Gallery, New York

55 Joel Sternfeld
*The Former Bryant's
grocery, Money,
Mississippi*, 1994
Colour coupler print
47.3 x 59.4 cm
Courtesy of the artist
and Luhring Augustine,
New York

84 Paul Strand
Toadstools and Grasses,
1928
Gelatin silver print
24.4 x 19.4 cm
© Aperture Foundation,
Inc., Paul Strand Archive

96 Thomas Struth
Audience 4, 2004
Colour coupler print
185.2 x 341.6 cm
© 2011 Thomas Struth

143 Thomas Struth
*Giulia Zorzetti vor einem
Bild von Francesco di
Mura, Chiesa Donna,
Romita, Napoli*, 1989
Colour coupler print
184.1 x 147.9 cm
© 2011 Thomas Struth

95 Thomas Struth
*Musée du Louvre 4,
Paris*, 1989
Colour coupler print
187 x 221 cm
© 2011 Thomas Struth

80 Hiroshi Sugimoto
*North Pacific Ocean,
Mt. Tamalpais*, 1994
Gelatin silver print
64.1 x 81.9 cm
© Hiroshi Sugimoto.
Courtesy Fraenkel
Gallery, San Francisco

81 Hiroshi Sugimoto
*Ionian Sea, Santa
Cesarea III*, 1990
Gelatin silver print
64.1 x 81.9 cm
© Hiroshi Sugimoto.
Courtesy Fraenkel
Gallery, San Francisco

40 Larry Sultan
*My Mother Posing for
Me*, from the series
Pictures from Home,
1984
Colour coupler print
45.4 x 55.6 cm
© The Estate of Larry
Sultan

28 Maurice Tabard
Jardin des Modes, 1931
Gelatin silver print
23.8 x 17.1 cm

112 Félix Teynard
*Gournah (Thebes),
Colosse de Gauche –
Decoration de la Face
Norde-Est du Trone*,
1851-52
Salted paper print from
calotype negative
24.3 x 30.6 cm

68 Carlton E. Watkins
Cape Horn near Celilo,
1867
Albumen silver print
55.56 x 70.8 cm

23 Carrie Mae Weems
*Untitled Outtake from
the Kitchen Table Series*,
1990
Gelatin silver print
72.4 x 71.8 cm
© Courtesy of the artist
and Jack Shainman
Gallery, NY

22 Edward Weston
Tina Modotti, Mexico,
1924
Platinum print
23.5 x 18.1 cm
© 1981 Center for
Creative Photography,
Arizona Board of
Regents

62 Minor White
*Vicinity of Dansville,
New York*, 1955
Gelatin silver print
26.7 x 35.4 cm
© Trustees of Princeton
University

121 Garry Winogrand
*World's Fair, New York
City*, 1964
Gelatin silver print
20.3 x 33 cm
© 1984 The Estate of
Garry Winogrand.
Courtesy Fraenkel
Gallery, San Francisco

151 Steef Zoetmulder
Van Nelle Tea, 1953
Gelatin silver print
48.6 x 38.7 cm
© Steef Zoetmulder/
Nederlands Fotomuseum

126 Piet Zwart
*Grass Covered in
Hoarfrost*, 1930
Gelatin silver print
17.1 x 12.4 cm
© Piet Zwart/ Nederlands
Fotomuseum

Published on the occasion of
the exhibition

Conversations
Photography from the Bank of America
Collection

Irish Museum of Modern Art, Dublin
21 February – 20 May 2012

Museo Del Novecento, Milan
30 September – 15 January 2012

Museum of Fine Arts, Boston
9 February – 19 June 2011

This exhibition is curated by
Mary Cremin, and is provided by
the Bank of America Merrill Lynch
Art in our Communities® Programme,
and was originally curated by the
Museum of Fine Arts, Boston.

IMMA Exhibition Team
Enrique Juncosa, Director
Seán Kissane, Senior Curator:
Head of Exhibitions
Mary Cremin, Project Curator:
Exhibitions
Gale Scanlan, Operations Manager
Cillian Hayes, Technical Crew
Supervisor

Publication
Edited by Mary Cremin
Designed by Peter Maybury, Dublin
Printing: MM Artbookprinting & repro /
Colorman, Dublin (co-production)
Repro: MM artbookprinting & repro
Prepared by the Irish Museum of
Modern Art, Dublin

First published in 2011 by
Irish Museum of Modern Art
Áras Nua-Ealaíne na hÉireann
Royal Hospital, Military Road
Kilmainham, Dublin 8
Ireland

Tel +353 1 612 9900
Fax +353 1 612 9999
E-mail info@imma.ie
Website www.imma.ie

Available through
ARTBOOK | D.A.P. /
Distributed Art Publishers
155 Sixth Avenue, 2nd Floor, New York,
N.Y. 10013
Tel (212) 627 1999
Fax (212) 627 9484

ISBN: 978-1-907020-81-0

This edition: © 2011 Irish Museum of
Modern Art, Dublin
Texts: © 2011 texts Irish Museum of
Modern Art and the authors
Images: © 2011 the artist and the artist
foundations for the images, except
where listed.

Irish Museum of Modern Art
Áras Nua-Ealaíne na hÉireann
20
1991–2011

Bank of America **Merrill Lynch**